IMAGES OF AMERICA

GREENVILLE

IMAGES OF AMERICA

GREENVILLE

PIPER PETERS AHERON

ARCADIA

This book is dedicated to Richard L. Aheron, who blessed me in marriage at the Fourth Presbyterian Church in Greenville, and to my niece, Erica Ann Peters, who was born in Greenville on a very special day, and to the fond memories of my Greenville friends, including David S. McKown and Mark Berry. Joy to you always.

Copyright © 1999 by Piper Peters Aheron
ISBN 0-7385-1550-7

First published 1999
Re-issued 2003

Published by Arcadia Publishing
an imprint of Tempus Publishing Inc.
Charleston SC, Chicago, Portsmouth NH,
San Francisco

Printed in Great Britain

Library of Congress Catalog Card Number: 2003107138

For all general information contact Arcadia Publishing at:
Telephone 843-853-2070
Fax 843-853-0044
E-mail sales@arcadiapublishing.com

For customer service and orders:
Toll-Free 1-888-313-2665

Visit us on the internet at http://www.arcadiapublishing.com

Contents

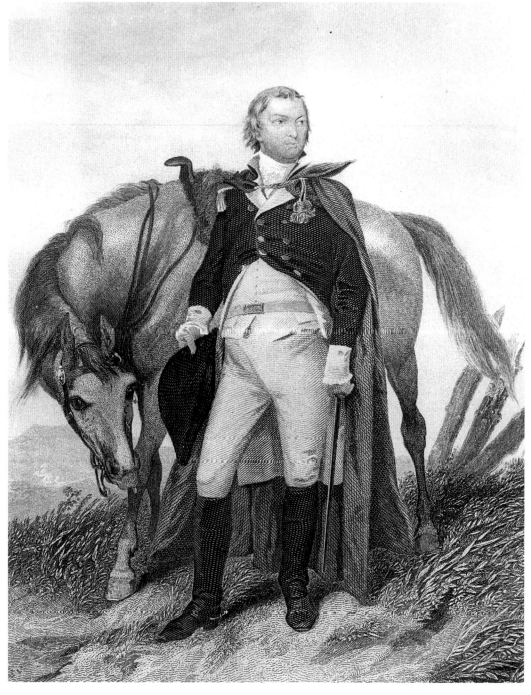

Territories were routinely named for the heroes who served the United States of America during the Revolutionary War. State legislative acts and archival records indicate that Greenville, originally spelled Greeneville, was probably named to honor General Nathanael Greene, a Rhode Island native. Greene sacrificed a personal fortune to keep his Southern militias from starving while they battled the British. (Special Collections, South Caroliniana Library, USC, Columbia.)

Introduction

They died fighting to preserve a hunter's paradise, a land where buffalo and deer grazed, where flocks of turkey and geese filled immense trees and inhabited canebrakes lining pristine streams or reedy rivers. They were the Cherokee, residents of present-day Oconee County. They battled the Catawbas of York County (about 1660). According to tradition, both sides suffered heavy casualties. The two nations agreed to share the piedmont crescent stretching northward to Virginia. No permanent American Indian camps were to exist there, and few did. Then the British arrived in Charleston, South Carolina, in 1670, and by 1747, white men regularly infiltrated the Carolina backcountry.

At first, the Cherokee welcomed them. The British were their allies, and amiable tradesmen, such as Richard Pearis, proved irresistible with offerings of liquor and guns. The Cherokee accepted Pearis, a married Presbyterian from Virginia who eventually fathered a Cherokee boy named George. It would be George, British by birth, that would enable the clever Pearis to legally obtain 50,000 to 100,000 acres of Cherokee land from the natives despite British laws prohibiting colonists from land ownership in the frontier.

Soon, more people traveled south along the Great Wagon Road from Pennsylvania, Virginia, and North Carolina to Great Plains, the name of Pearis's plantation along the Reedy River. Some of these settlers included the following prominent families: the Hamptons, who settled around the South Tyger River; and the Earles, who settled along the Pacolet River. As the Revolutionary War approached, clashes between settler and Cherokee, Patriot and Tory, intensified. The Cherokee lost their hunting ground. The Patriots ousted Indian/Tory ally Richard Pearis, confiscating Pearis's property and burning his trading post, gristmill, and sawmill to the ground. Pearis escaped to the Bahamas. Despite his petitions, he never again saw Great Plains, a land shadowed by Paris Mountain, a bluff named for him. The ancient hunting preserve, once a part of the British Empire, became a real estate venture for attorney Lemuel J. Alston. By 1801, Alston owned 11,028 acres of Pearis's Great Plains.

Great Plains became a part of Greenville County through the County Court Act of 1785. Alston, a visionary, donated some land for the construction of a county courthouse. He also created a plat and labeled the mapped area Pleasantburg, a village that would divide the county named in an effort to honor General Nathanael Greene. North of the hamlet's log courthouse were the foothills called the Dark Corner. Southward lay the Possum Kingdom, flatlands best utilized for farming. Greenville, both county and city, had finally been organized, with Greenville the beneficiary of low country merchants' dealings. Coastal plantation owners began to vacation at local mineral springs, while drovers pushed herds of cattle, sheep, hogs, and turkeys from Kentucky and Tennessee through Greenville to Charleston. This profitable activity caught the eye of a Lincolnton, North Carolina saddle maker, Vardry McBee. In 1815, McBee gave Alston $27,550 for the Alston estate, or Prospect Hill.

Although McBee did not reside in Greenville until 1835, the town and the county immediately enjoyed his influence. His wide-ranging interests in agriculture, textiles, transportation, and education made him the cornerstone of the community. McBee and his family operated several mills. He provided land for a multitude of various religious denominations and their sanctuaries. He also provided land for schools, including Furman academies. He recruited the railroads into the area, and under McBee's leadership, Greenville blossomed.

As the twentieth century approached, the Southern textile boom accelerated demands on the suburbs for better transportation, housing, and education. Local businessmen and Northern investors began to address the needs of a rising new middle class in a county and a city intricately linked to each other like no other part of South Carolina. By 1907, Greenville had unseated Charleston's political influence within the state, becoming a manufacturing trade center as well as a training ground for federal troops for the forthcoming World Wars.

But Greenville flourished in peace times, too, enjoying the attention of notable men and women across the globe. For example, Albert Einstein once strolled Furman University campus; Billy Graham studied at Bob Jones University; and Jesse Jackson still visits Greenville Tech. From the 1800s to the 1960s, the famous, along with many Greenvillians, celebrated education, arts, and sports as an integral part of the multi-cultural South. Never before is this more apparent than in these seldom-seen photos from the institutions, families, and businesses that form Greenville's civic villages.

This book is an incomplete, pictorial history of Greenville. It is a short work intended to provide the reader with a sense of evolution about this complex community that struggles with many conflicting personalities: Progressive versus Traditional, Urban versus Rural, and Southern versus International. It is my hope that these images of daily life bring into brief focus Greenville's past, revealing an area and a people noted for a vitality and strength that will last them well into the twenty-first century.

Piper P. Aheron

one

From Rivers
to Resorts

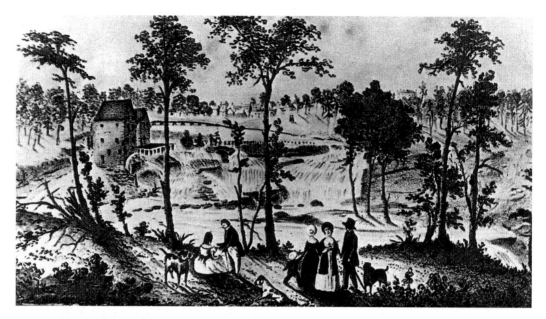

Between 1784 and 1798, attorney and politician Lemuel J. Alston, originally from North Carolina, purchased the old Richard Pearis plantation, Great Plains. Alston created a plat and labeled the mapped area Pleasantburg. The term seemed appropriate, but settlers preferred to simplify the community's name from Greenville Court House Village of Pleasantburg to just Greenville. Presently, Highway 291 is called Pleasantburg Drive in remembrance of Alston's real estate project. (From the 1844 litho by T. Addison Richards for *Orion Magazine*; Special Collections, South Caroliniana Library, USC, Columbia.)

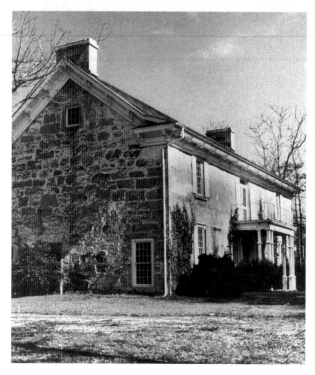

This colonial stone house on Buncombe Road served the county as a tavern, a stagecoach stop, and a post office. The Rock House belonged to patriot Captain Billy Young. The house was built about 1819 while the State Road to Asheville, North Carolina was being completed. (The Marsh Collection, South Caroliniana Library, USC, Columbia.)

This marker stands on White Horse Road near Pendleton Road. Erected November 26, 1958, the marker explains that Richard Pearis was not alone in the frontier. Interestingly, accounting books from the Alexander McBeth & Company General Store indicate that liquor was the favorite item traded. (Photo by R. L. Aheron.)

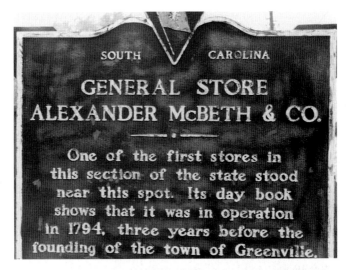

SOUTH CAROLINA

GENERAL STORE
ALEXANDER McBETH & CO.

One of the first stores in this section of the state stood near this spot. Its day book shows that it was in operation in 1794, three years before the founding of the town of Greenville.

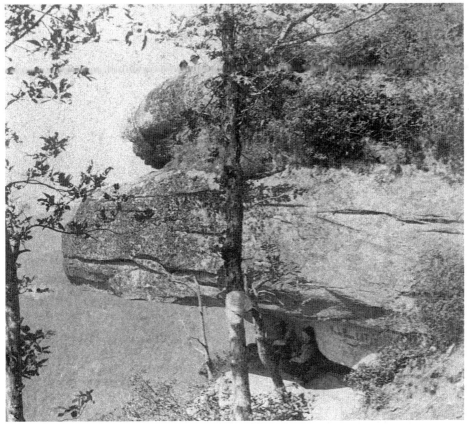

Greenville County is divided by the city. Farmlands dominate the southern half, and mountains dominate the north. Referred to as "the Dark Corner," Caesar's Head is the highest point in Greenville. In this 1890s view, two men sit in the rock's shade while two men rest on its top. A popular resort east of Caesar's Head existed from the 1850s to the late 1950s. (Special Collections, South Caroliniana Library, USC, Columbia.)

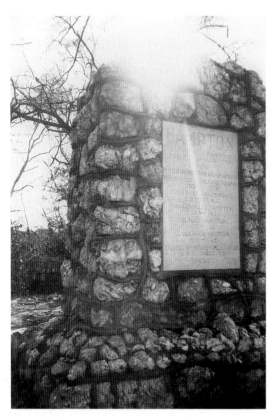

In 1776, life ended for the Hamptons, who had settled beside the South Tyger River. Anthony, his wife, his son Preston, and an infant grandson died while angry Cherokees burned down the farm. Edward Hampton survived the carnage only to be murdered by Tories in 1781. Wade Hampton also survived the family's massacre because he had been traveling out of state. While the incident happened outside Greenville County, the Hampton Massacre shook Pleasantburg villagers. This rock marker northeast of Greer is on Old U.S. 29 (or Wade Hampton Boulevard), named in honor of Governor Wade Hampton III. (Photo by P.E. Peters.)

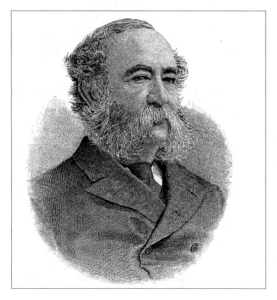

A direct descendant of the massacred Hampton family, Confederate Cavalry general Wade Hampton III became governor in 1876. The conservative Democrat's best supporters included the 1865 provisional governor of South Carolina, Benjamin F. Perry of Greenville. Hampton, who frequently visited Greenville, also received support from both African Americans and Caucasian voters. (Courtesy of Catherine Hughs and the Biemann family collections, Walhalla.)

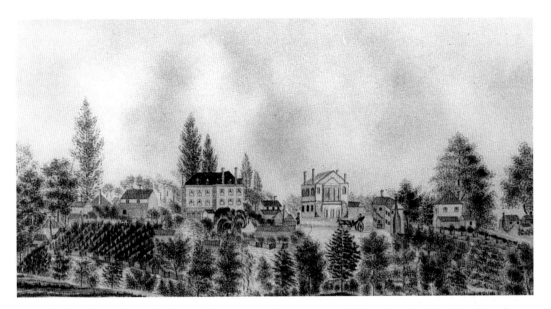

On the Pleasantburg plat, Lemuel J. Alston named two streets—Main, originally "The Street"; and McBee Avenue, or "The Avenue." In all, Alston offered 52 lots for sale. Isaac Wickliffe made the first purchase, and Vardry McBee purchased the remainder of Alston's properties. In this 1825 painting by Dr. Joshua Tucker, the two-story Mansion House (left) and the Record Building (semi-circular stairs) dominate Main Street. Village life centered around court sessions held twice a year. (Courtesy of Abby Aldrich Rockefeller Folk Art Center, Virginia, and South Caroliniana Library, USC, Columbia.)

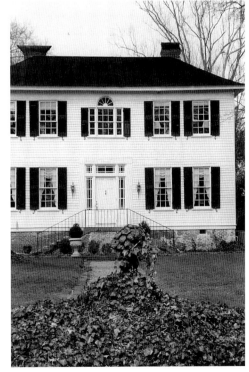

Lemuel J. Alston and Elias Earle (1762–1823) were Greenville's top citizens. Earle moved from Virginia to Greenville at age 25. He constructed his home, the Poplars, on the northeast corner of Rutherford and Buist Streets. Earle also built the Great Wagon Road from South Carolina to Tennessee. He served as a state legislator and U.S. congressman, frequently running against Lemuel Alston. This city house on James Street is considered the second Elias Earle home, also named the Oliphant House, which originally faced southeast to Buncombe Road. (Photo by P.E. Peters.)

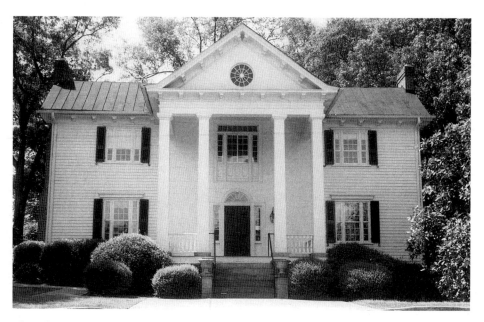

The Kilgore-Lewis House (*c.* 1832) was relocated from Buncombe Road to 560 North Academy, or the Waddy Thompson estate and gardens. The stone spring is nearby, and the Greek-Revival home serves as headquarters for the Greenville Council of Garden Clubs, Inc. (Photo by R.L. Aheron.)

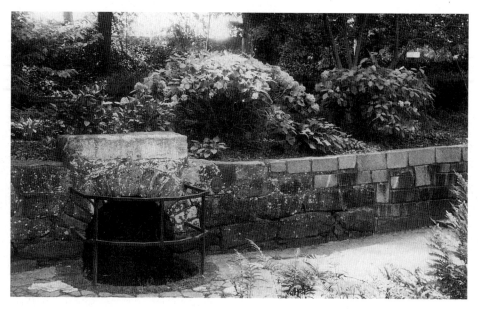

"Thank God For Water" has faded from the keystone of this spring at the Kilgore-Lewis House. Early settlers relied on springs and rivers for their health. As early as 1827, when the Gaol Springs and Rock Springs had become polluted, the villagers declared themselves conservators. They contributed a total of $27 to have the springs cleaned and improved. This old stone spring, the centerpiece of the Greenville Garden Club's terraced gardens, is also considered the Waddy Thompson Spring. (Photo by R.L. Aheron.)

Vardry McBee (1775–1864), from the Gaffney, South Carolina area, moved to Lincolnton, North Carolina, where he learned the saddle trade from his brother-in-law. While living in Lincolnton, McBee purchased Lemuel J. Alston's estate, approximately 11,028 acres for $27,550. McBee believed Greenville's waterpower and its proximity on the wagon road across the mountains would prove highly profitable. McBee chose to reside in North Carolina until 1832. (Portrait from *DeBow's Review*, 1852; Special Collections, South Caroliniana Library, USC, Columbia.)

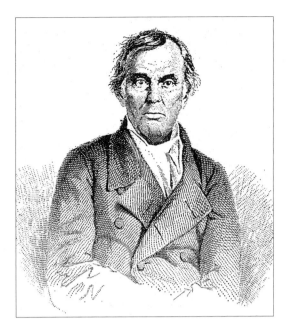

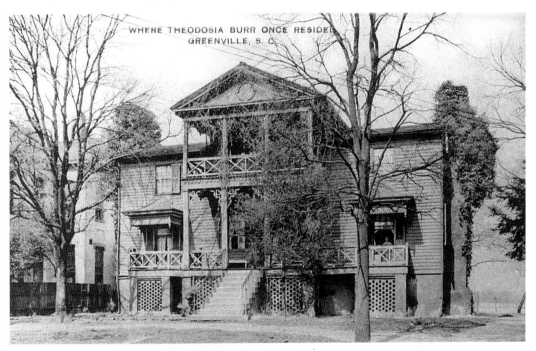

When it was constructed in the late 1700s, Prospect Hill sat 600 feet from the main road, or Pearis's Wagon Road, which continued to present-day White Horse Road and into the hillsides of the district. By the 1900s, Prospect Hill was located at Westfield Street and McBee Avenue. Prospect Hill also became one of Greenville's first hotels after Alston sold it to Vardry McBee. In 1815, Alston relocated to Clarke County, Alabama, where he died in 1836. In 1835, Vardry McBee finally moved from Lincolnton, North Carolina, to Greenville. McBee lived in this house until his death in 1864. In 1920, Prospect Hill was demolished. (Special Collections, South Caroliniana Library, USC, Columbia.)

Right: County residents enjoyed Vardry McBee's influence as much as the townspeople. John Adams, McBee's overseer, built this octagonal Methodist chapel in Conestee for the workers of the Reedy River Mill. Vardry McBee frequently offered land for the construction of religious and educational facilities, including Furman academies, Christ Episcopal, and many others. McBee is buried at Christ Episcopal Church on Church Street in the city. (Marsh Collection, South Caroliniana Library, USC, Columbia.)

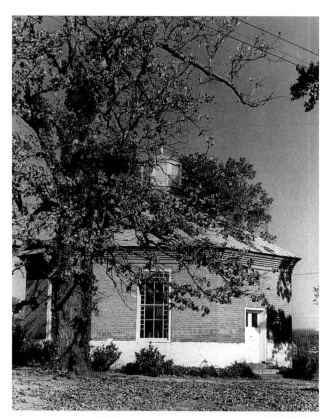

Below: Just off Rutherford Road on Earl Street stands the summer home of Governor Henry Middleton, son of Arthur Middleton, a signer of the Declaration of Independence. Whitehall, a Charleston-styled house, was occupied by the Middletons from 1813 to 1820. During the Spanish-American War, when U.S. troops were stationed in Greenville at Camp Wetherill, Whitehall served as a residence and dormitory for nurses. (Courtesy of the Jim DeYoung family.)

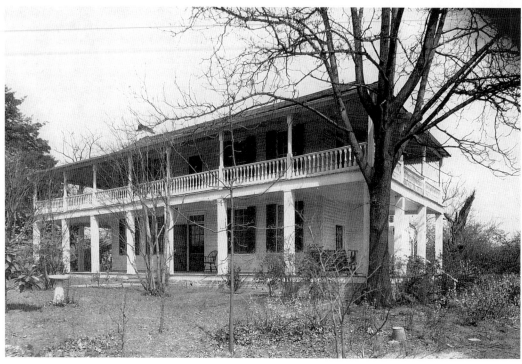

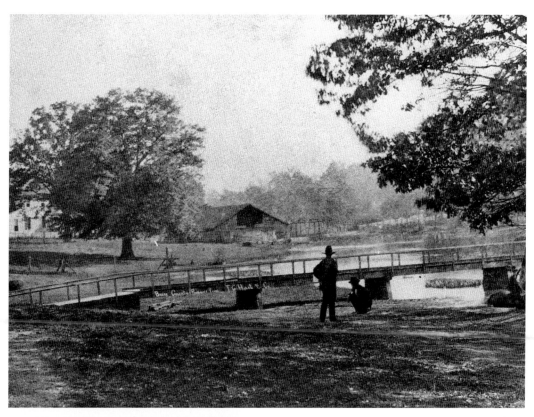

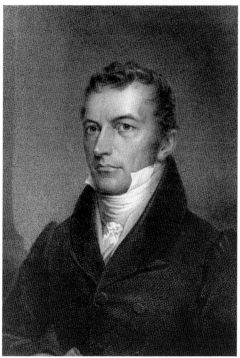

Above: Two men rest beneath a shade tree as the Reedy River meanders under the 1880 Gower's Footbridge. As early as 1835, the Gower family made their mark by building a carriage factory on river lands owned by Vardry McBee. (Special Collections, South Caroliniana Library, USC, Columbia.)

Left: Joel Roberts Poinsett (1779–1851), son of a wealthy Charleston doctor, served the United States in Chile and Argentina and later became an ambassador to Mexico in the 1820s. He also served as a state legislator and headed the South Carolina Board of Public Works (1819–1821). In 1837, Poinsett became the secretary of war for President Martin VanBuren. His summer home was located in the Tanglewood section west of Greenville off White Horse Road. Many Greenvillians respected Poinsett, a gentleman gardener who is nationally recognized for naturalizing the Mexican Christmas Flower, or the Poinsetta. Poinsett's name appears on a hotel, a highway, a private dining club, and a mill village. Joel Poinsett died en route to the upstate from Georgetown, South Carolina, in 1851. (Special Collections, South Caroliniana Library, USC, Columbia.)

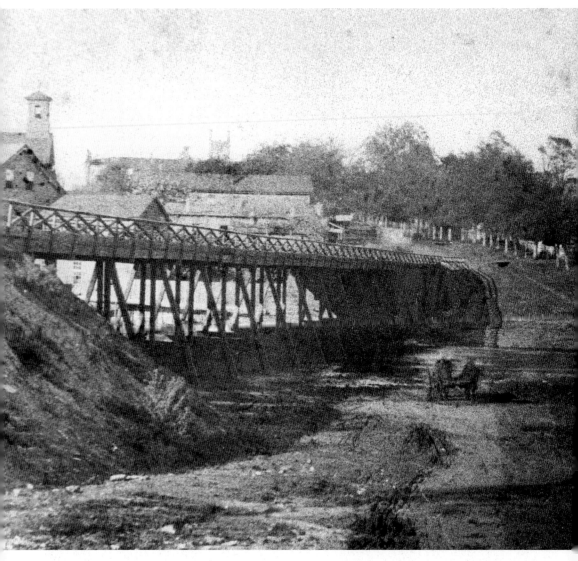

Above: Bridges were important to early settlers, but they were mostly for horse-riders or pedestrians. In this view, a heavily loaded wagon rolls down a slope toward the shallow crossing of the Reedy River. South Main Street and the towers of the third courthouse are visible in the distance. At the left is Gower's Bridge Number 2, also called Gower Bridge over the Reedy, which was named for Mayor T.C. Gower. (Special Collections, South Caroliniana Library, USC, Columbia.)

Opposite below: In summer, coastal planters escaped malaria and humidity by traveling to the Upstate. This trend continued, so William Toney built the 23-room Mansion House Hotel to accommodate the visitors. It occupied lots seven and eight of the original city plan of 1797. Its interiors featured luxuries like marble tile, glass chandeliers, and a rope elevator. Since the structure was located close to the Record Building, politicians such as John C. Calhoun frequently roomed at the Mansion House. Presently, the Poinsett Hotel on Main Street occupies the lots where the Mansion House once stood. (Special Collections, South Caroliniana Library, USC, Columbia.)

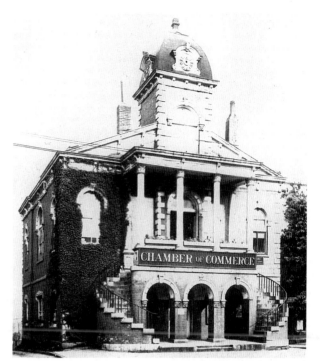

Right: In 1889, the YMCA and chamber of commerce occupied parts of the Record Building (erected 1824 and demolished 1924). The fireproof building is attributed to designer Robert Mills, one of the nation's first professional architects. (Special Collections, South Caroliniana Library, USC, Columbia; also, Special Collections, Furman University, Greenville.)

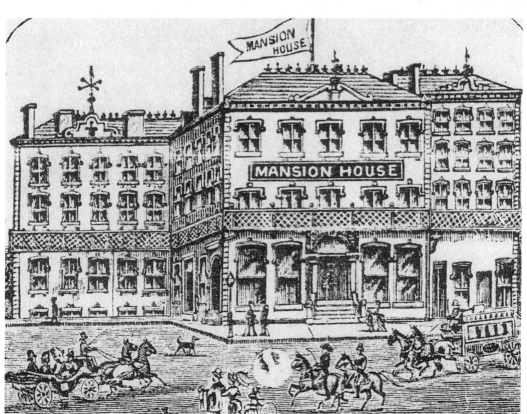

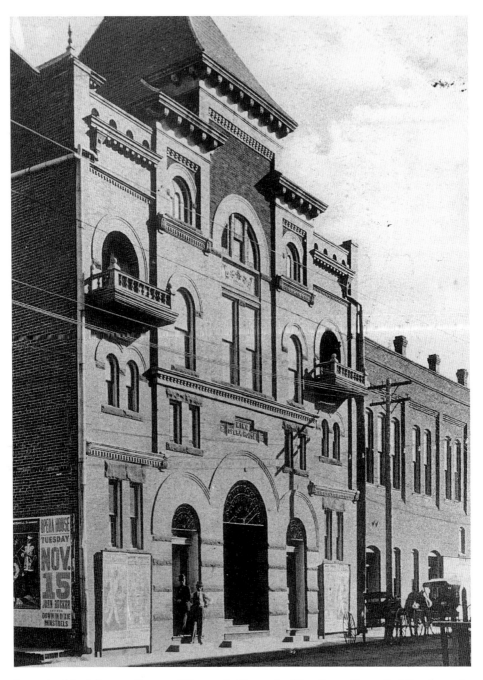

Located at North Laurens Street and Buncombe Street, the King Opera House Building (erected 1895) is mentioned in the 1896 City Directory, which was compiled by A.E. Sholes. Notice the playbill, which advertises John Rucker and the Down In Dixie Minstrels Show for November 15. The Opera House was for whites and white performers only. Presently, the site of the Opera House is the Coffee Street Mall, also called Piazza Bergamo, where the Bank of America high-rise stands. (Special Collections, South Caroliniana Library, USC, Columbia.)

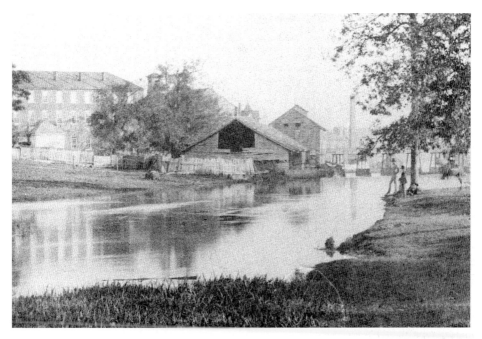

Factories, warehouses, and mills crowded the Reedy River by the 1860s. At the left of this 1890s view is the site where the Peace Center for the Performing Arts would eventually stand a century later. Interestingly, no resorts or hotels were located on this scenic part of the river. (Special Collections, South Caroliniana Library, USC, Columbia.)

Resorts for Lowcountry planters visiting the region began to pop up near mineral springs in the 1830s and the 1840s. In 1838, Dr. Burwell Chick from the Charleston/Newberry District was hunting deer when he stopped at Asa Crowder's home. Crowder asked American Indians from the Enoree River area to guide Chick to Lick Springs. In 1840, Dr. Chick opened a resort at Lick Springs, roughly 5 miles from the village of Greenville. Chick also sold lots to individuals, who built summer cottages on the land. Chick died in 1847, but the resort continued. (Special Collections, South Caroliniana Library, USC, Columbia.)

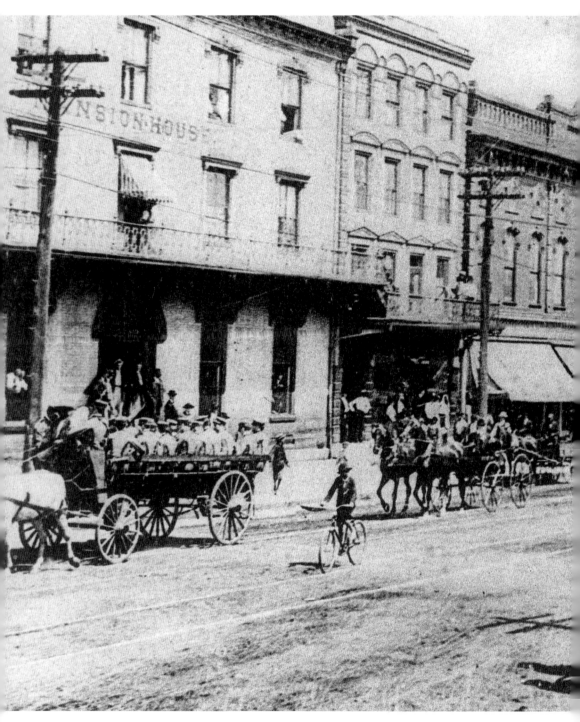

In 1832, South Carolina adopted the Ordinance of Nullification. Greenvillians opposed it, a pro-Union act though Greenville was a slaveholding society. Unfortunately, anarchy prevailed. When Union Major General George Stoneman received word that Confederate President Jefferson Davis had abandoned Richmond and was moving South through the Carolinas, Stoneman dispatched a cavalry to intercept

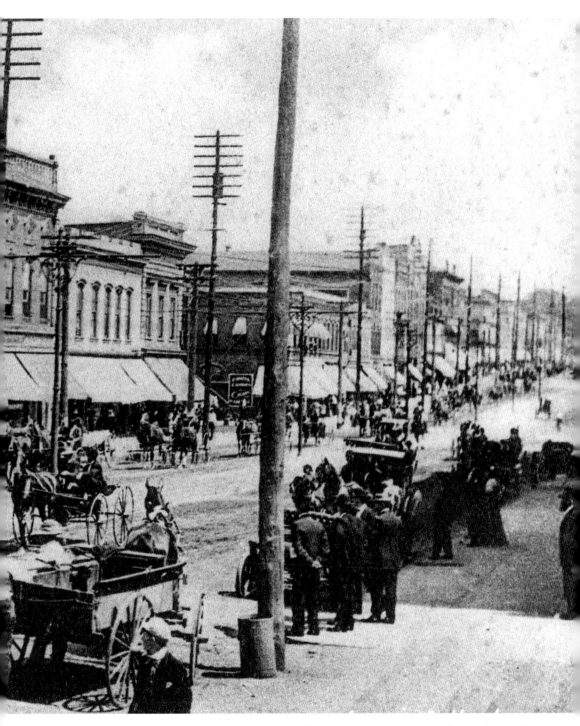

Davis. On May 2, 1865, Major James Lawson crossed the mountains and rode down Buncombe Road to Greenville. His troops searched houses. A white man and a former slave died, but overall, destruction was minimal. (Special Collections, South Caroliniana Library, USC, Columbia.)

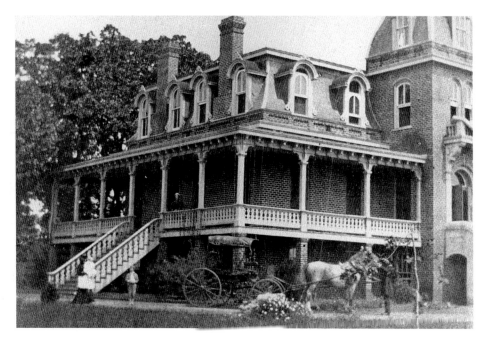

Horse and buggy await Benjamin Perry in front of the newly constructed Sans Souci, a brick, French Second Empire house with a mansard roof. The interior's focal point included a circular stairway. The community of Sans Souci, located northwest of the city just off the Old Buncombe Road, is named for Perry's unique home. (Special Collections, South Caroliniana Library, USC, Columbia.)

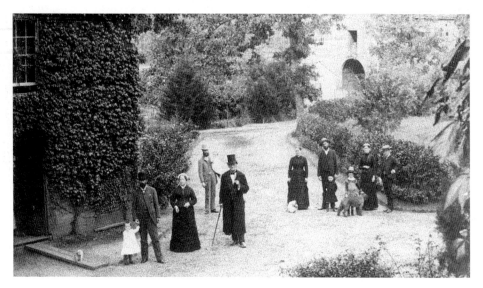

Benjamin F. Perry (black top hat, long black coat) and his family stroll the grounds of Sans Souci. After Perry's death, Sans Souci became a fashionable school for women until businessmen purchased it in 1905. They created the Sans Souci Country Club, which offered Greenville's elite a nine-hole golf course and clay tennis courts. The country club remained at Sans Souci until 1923. (Special Collections, South Caroliniana Library, USC, Columbia.)

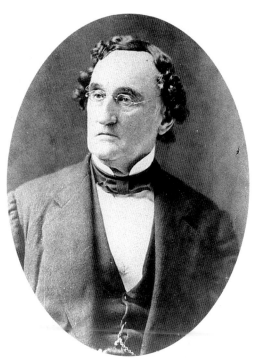

A slave owner with a passion for the Union, Benjamin Franklin Perry (1805–1886) served as an attorney, an editor, and a journalist in Greenville. He founded the *Greenville Mountaineer* (1829) and the *Southern Patriot* (1846), a pro-Union newspaper rivaled by Turner Bynum's *Southern Sentinel*. Turner Bynum, who frequently and bitterly attacked Perry, eventually met Perry in a duel; Perry won, but as he matured, he grew to regret the death of Turner Bynum. (Special Collections, South Caroliniana Library, USC, Columbia.)

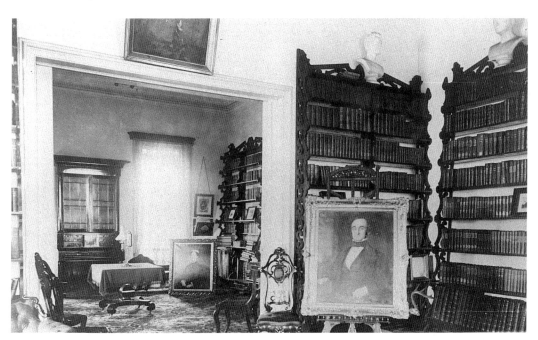

The library at Sans Souci (1871) was Benjamin Perry's joy. He purchased many rare law books for it. He also added his writings and correspondence to its contents. The portrait in the foreground is Perry at age 48. The portrait on the floor features his daughter, Mrs. William Beattie. Perry died at Sans Souci on December 3, 1886. (Special Collections, South Caroliniana Library, USC, Columbia.)

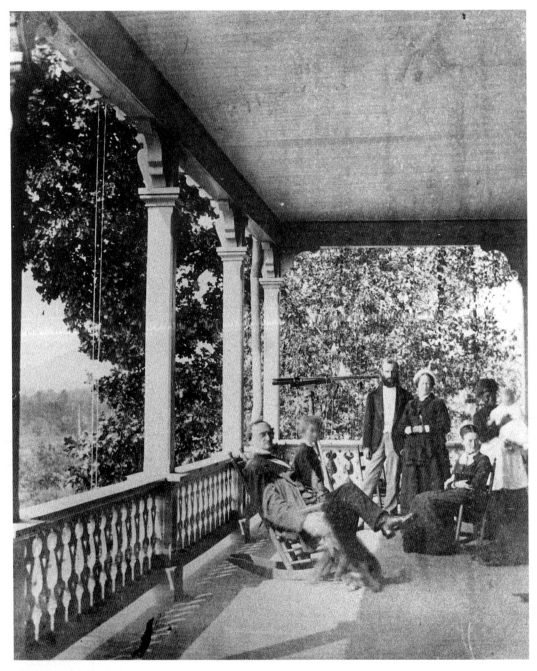

Benjamin F. Perry opposed Secession, but when South Carolina left the Union, Perry served the Confederate States of America. He became a C.S.A. government court commander (1862), a district attorney (1863), a district judge (1864), and provisional governor (1865). In 1866, Perry was elected to the U.S. Senate, but the Senate refused him the seat. Perry decided to retire to his home, Sans Souci, which he built in 1870. In this view, Perry reclines in a rocking chair on the porch of Sans Souci. He pats his dog and enjoys the company of his children and grandchildren. (Special Collections, South Caroliniana Library, USC, Columbia.)

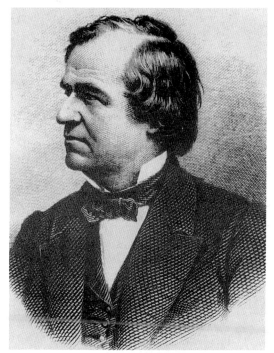

Andrew Johnson, son of a hotel porter, left his hometown of Raleigh, North Carolina, and moved to Greenville around 1826. George Boyle, a tailor who had a shop at the north end of Main Street, hired young Johnson to assist him. Johnson eventually relocated to Greenville, Tennessee, where he entered into a successful political career. When Lincoln was assassinated, Johnson became president in 1865. President Andrew Johnson appointed Benjamin Perry provisional governor of South Carolina in 1865. (Courtesy of the Aheron family.)

Near the entrance of Springwood Cemetery on Main Street is a park filled with memorials. In 1923, the Confederate Monument, erected in 1892, was moved to this location from the center of North Main and College Street, where it had interfered with Greenville's increasing traffic. A few yards from the Confederate Monument is a marker honoring the signees of the Ordinance of Secession, erected in 1961 by the Greenville County Centennial Commission. (Photo by R.L. Aheron.)

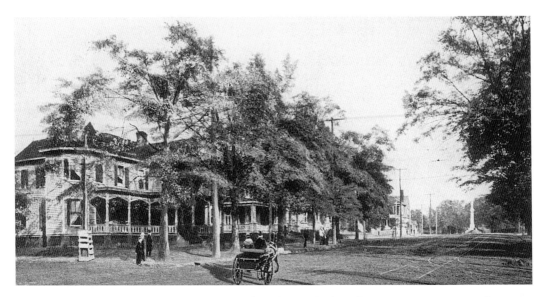

In 1910, a notable address for influential citizens would be North (also called Upper) Main Street and West North Street. This postcard view includes the corner residence and main offices of Earle and Earle, both physicians. Other dwellings in this view belonged to Eugene Bates, Hyman Endel, and D.W. Ebaugh, just to name a few. The Confederate Monument stands in the center of the dirt road. (Special Collections, South Caroliniana Library, USC, Columbia.)

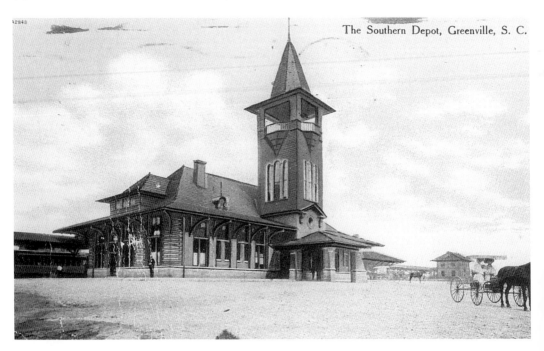

The Southern Depot, Greenville, S. C.

At the west end of Washington Street, this Romanesque Revival–styled station greeted incoming passengers (erected 1890, demolished 1988). The railroad was completed around 1872. Railroads accelerated Greenville's growth throughout most of the twentieth century. (Special Collections, South Caroliniana Library, USC, Columbia.)

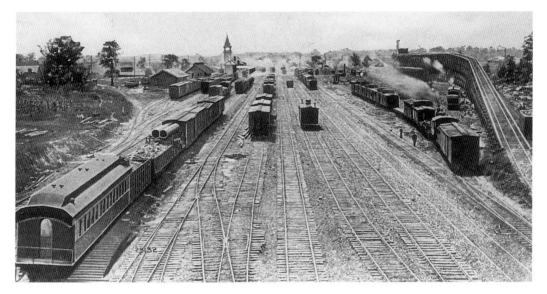

Vardry McBee lured early railroad lines to Greenville. These small railroads were individually owned. After the Civil War, the Southern Railway Company unified the rails into one great system. This made Greenville easily accessible from Atlanta to New York and from the Tennessee mountains to the Carolina coast. The railroad yards and the coal chutes were located on Washington Street. In 1906, a roundhouse existed, but it closed in 1954. (Special Collections, South Caroliniana Library, USC, Columbia.)

CAMP SEVIER
ONLY
THREE MILES
ON
P. & N. ELECTRIC
RAILWAY

50 ROOMS WITH
BATH

CAMP
WADSWORTH
ONLY
FIFTEEN MILES
ON
P. & N. ELECTRIC
RAILWAY

50 ROOMS
WITHOUT BATH

CHICK SPRINGS HOTEL
CHICK SPRINGS, S. C.
MODERN FIRE PROOF HOTEL.
ALL OUTSIDE ROOMS WITH STEAM HEAT, HOT AND COLD WATER AND TELEPHONES.
OFFERS SPECIAL RATES FOR EARLY RESERVATIONS
AMERICAN PLAN RATES BY THE WEEK EUROPEAN PLAN RATES BY THE WEEK
$14.00 UP SINGLE, $25.00 UP DOUBLE $7.00 UP SINGLE, $10.00 UP DOUBLE
DRINK CHICK SPRINGS WATER AND EAT ANYTHING YOU WANT

This colorfully illustrated rate card touts all the luxuries of the new Chick Springs Hotel. Chick Springs was located off Wade Hampton Boulevard, or old U.S. 29, in Taylors. (Special Collections, South Caroliniana Library, USC, Columbia.)

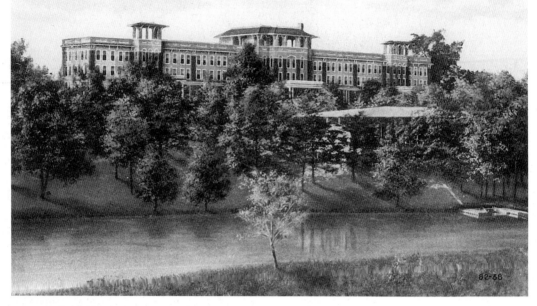

The New Modern Hotel, Pavilion and Lake at Chick Springs, S. C.

82-38

Above: When Chick died, his two sons added billiards and a ten-pin alley to the resort. In 1857, Chick Springs became the property of Franklin Talbird of Beaufort and J.T. Henry of Charleston. Alfred Taylor managed it. Taylors, or Taylor's Station, is named for Alfred Taylor, who kindly donated the land for a railroad station and a church. (Special Collections, South Caroliniana Library, USC, Columbia.)

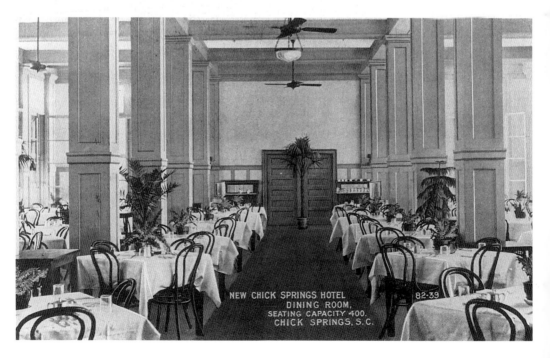

NEW CHICK SPRINGS HOTEL
DINING ROOM,
SEATING CAPACITY 400,
CHICK SPRINGS, S.C.

82-39

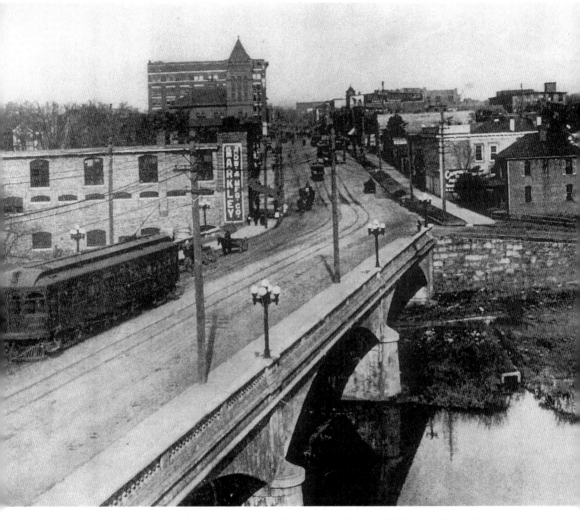

Above: In this photo, horse-drawn buggies and trolley cars cross the Reedy River Bridge on Main Street. Originally, the trolley cars were tracked and moved by mules. Electricity eventually came to the Upstate in the latter part of the nineteenth century, and by 1898, George M. Bunting & Associates of Philadelphia operated the first electric streetcar railway system. The company's first completed "belt line" in 1904 carried people to Greenville businesses and mills such as Woodside Mills, Monaghan Mills, and the American Spinning Company. Finally, trolley service existed from Buncombe Street to Augusta Road to Main Street. (Courtesy of the Jim DeYoung family.)

Opposite below: In the 1800s, people vacationed at Greenville resorts. Some of the better inns included Mansion House, Altamount Hotel, and Fountain Inn (established in 1886). Taylors flourished due to Chick Springs Hotel as did the Town of Fountain Inn because of its hotel. Trains and trolleys made getting to the resorts easier. The new Chick Springs Hotel (*c.* 1904), with its new dining room, could seat 400 people. It was one of the last resorts to close. (Special Collections, South Caroliniana Library, USC, Columbia.)

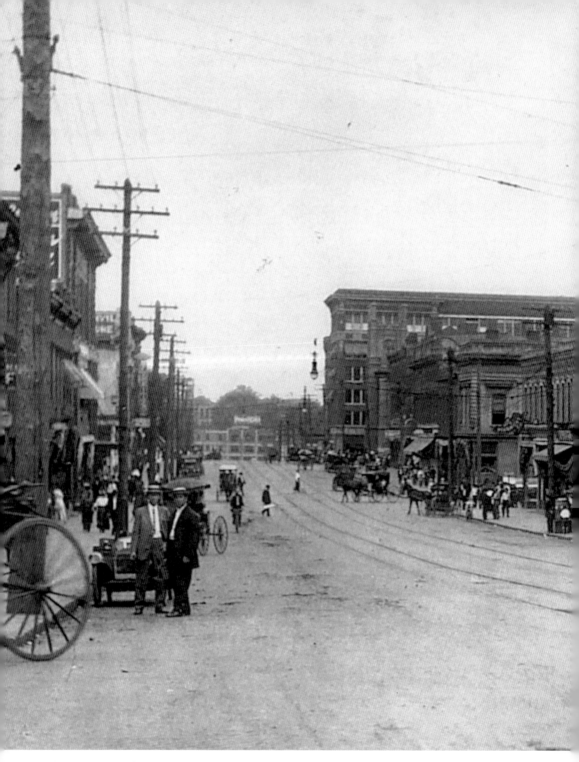

This 1914 view is from the bricked junction of Main and Washington. Greenville's junctions were bricked. The rest of the street was clay. Progress and technology soon required more durable material to be utilized. (Special Collections, South Caroliniana Library, USC, Columbia.)

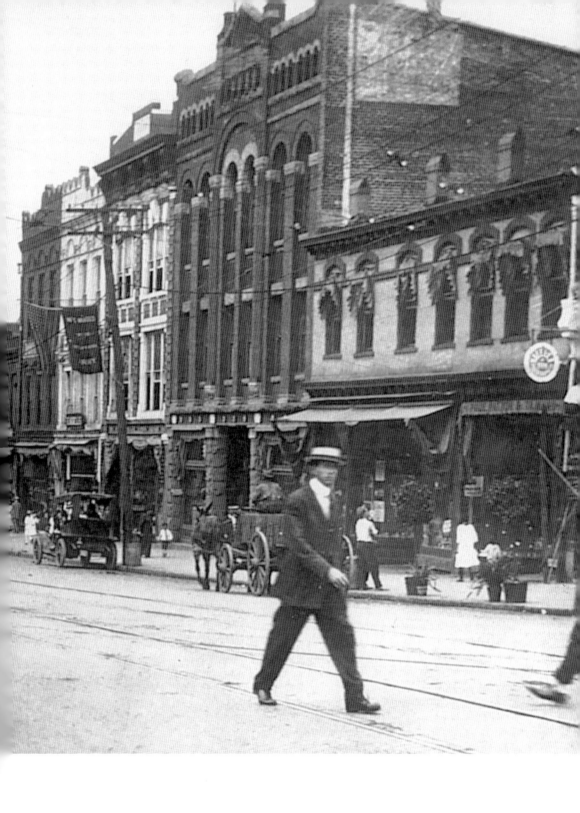

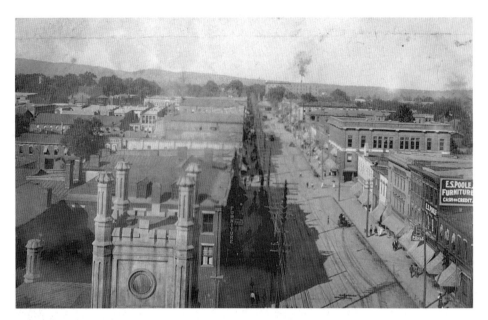

Above: After the Civil War, Greenville County's population grew. Under the leadership of William T. Shumate, Manning Creer's farm became Greer, South Carolina, in 1875. Simpsonville (named for blacksmith Peter Simpson) and Butler's Crossroads (later called Mauldin), both located along the Greenville-to-Laurens Road (Old Stage Road), expanded city services to complement growth brought about by railroad traffic and modern textile mills. The City of Greenville (pictured here) also expanded municipal services and strengthened its infrastructure. (Courtesy of the Jim DeYoung family.)

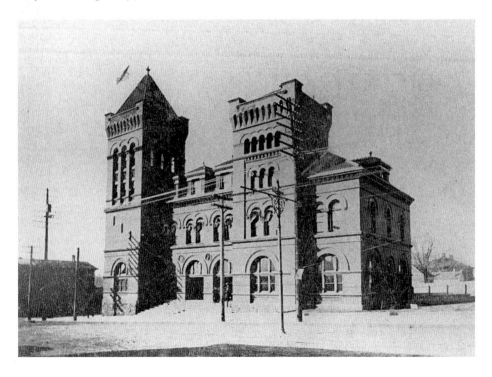

Above: Architectural details of the 1892 post office/city hall reveal terra-cotta tiles in the towers. Pre-casted terra cotta and many of the hand-crafted elements within the structure's interior were considered rare and valuable at the time the building was demolished. (Marsh Collection, South Caroliniana Library, USC, Columbia.)

Opposite below: Greenville's first post office was authorized to function in the courthouse in 1795. By 1892, villagers mailed letters from this Victorian Romanesque–styled building on the north corner of South Main and West Broad Streets. In 1935, this building became the city hall. The Post Office Building was razed in 1972 to make room for the new city hall, a sleek high-rise. (Special Collections, South Caroliniana Library, USC, Columbia.)

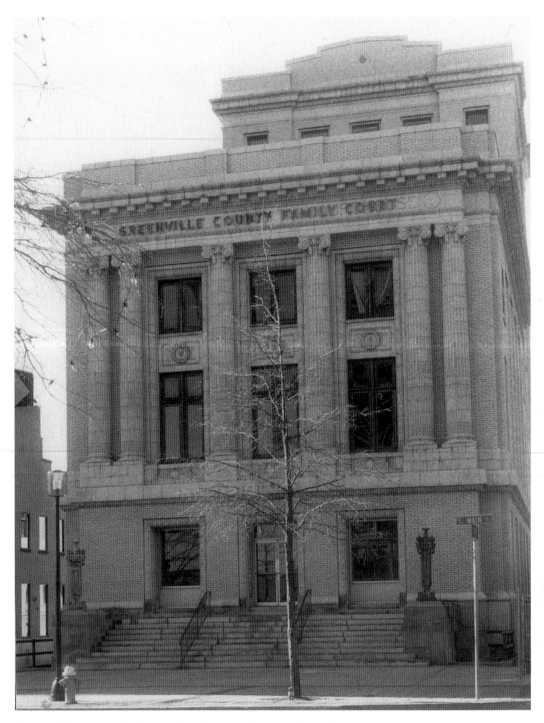

Built in 1916, Greenville County Courthouse number 4 is a beautiful, yet inconspicuous structure in the shadows of the Poinsett Hotel. This courthouse replaced the third Gothic-styled courthouse. Greenville's first courthouse was a log structure, erected at the center of the square formed by the intersection of Main and Court Streets. (Photo by R.L. Aheron.)

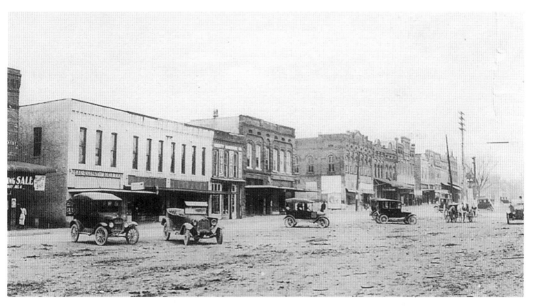

No paved roads existed in Greenville until 1883, when the city council approved the paving of Main near Broad Street. Between 1888 and 1904, four water reservoirs were constructed at Paris Mountain. Also, in 1888, an electric powerhouse was built on Broad Street. By 1891, this power plant became the Greenville Gas, Electric, Light, and Power Company. (Special Collections, Furman University, Greenville.)

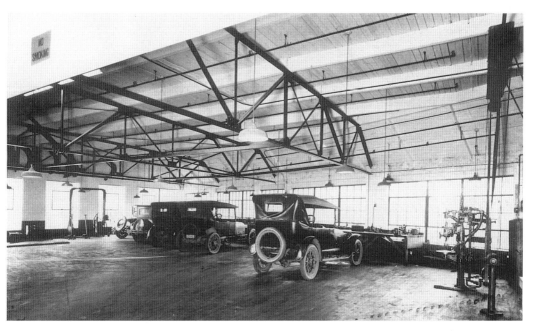

In 1904, there were five cars in the county. In 1909, Greenville adopted a speed limit of 15 m.p.h. By 1914, there were 1,038 cars in Greenville, the largest number in any county in the state. Greenvillians acted quickly to improve the quality of roads in the region. (Courtesy of the Jim DeYoung family.)

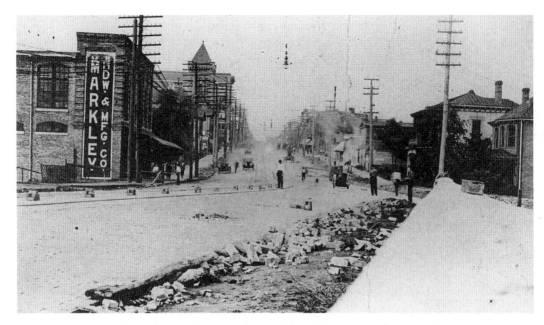

From 1820 to 1860, the population of the city of Greenville tripled. In 1869, the city officially incorporated. By 1883, with more than 149 stores and several banks open for business, Greenville began a great building boom. E.R. Horton Jr. (the man in the street's center) surveys the construction on Main Street's bridge in this photo. Bricks and cobblestones had to be removed from junctions before paving could begin. The work was slow, yet by 1916, Greenville was the state's leading road builder. In 1917, the state highway department formed, and Greenville continued to pave more roads—North Main Street Extension (1926), Cleveland Street (1929), and McDaniel Avenue (1930). By 1932, Greenville had more than 220 miles of paved road within the county. (Special Collections, South Caroliniana Library, USC, Columbia.)

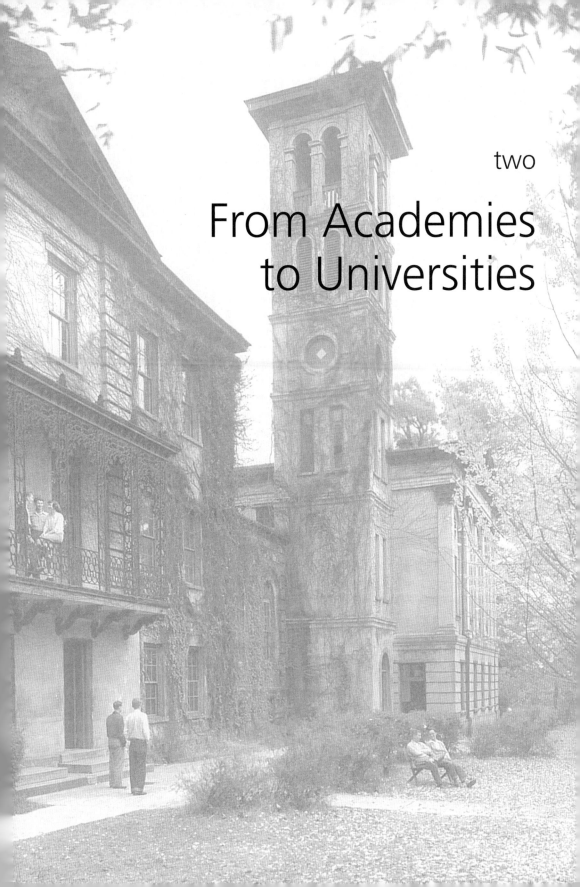

two

From Academies
to Universities

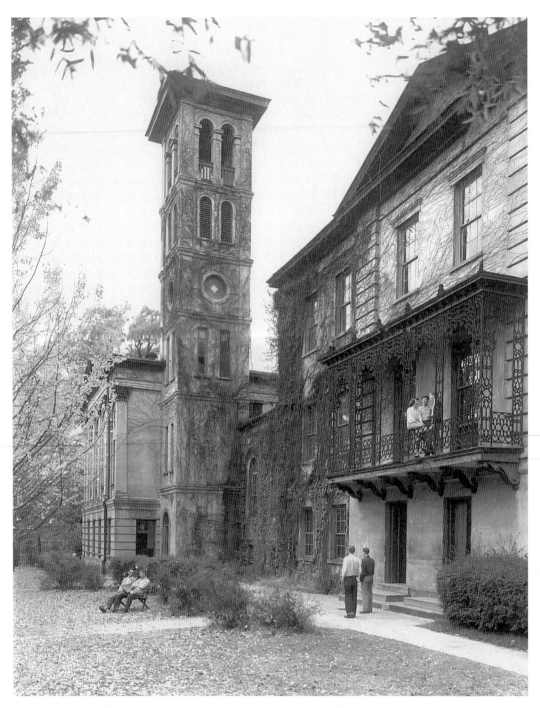

Edward C. Jones of Charleston designed the Furman Campus (built 1854, demolished *c.* 1961) on University Ridge between Augusta and Church Streets. Jones created an Italian-style bell tower, which chimed after Southern victories in the Civil War. This tradition passed to a replica of the tower on the campus at Poinsett Highway. It chimes after every win of a Furman athletic event. (Special Collections, South Caroliniana Library, USC, Columbia; also, Special Collections, Furman University, Greenville.)

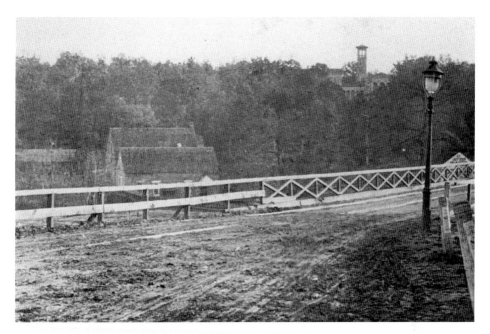

Gower Bridge linked the village to University Hill or University Ridge. One can see the square bell tower of Furman Academy in the distance. A replica of this tower now stands at Furman University, located off the Poinsett Highway, 5 miles north of the city. (Special Collections, South Caroliniana Library, USC, Columbia.)

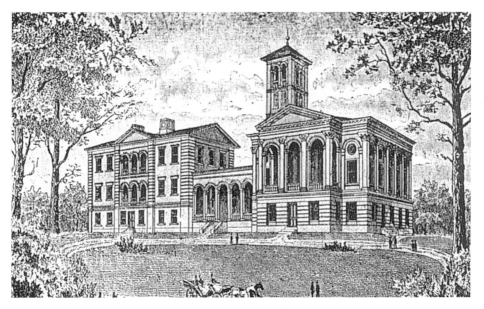

Greenville became a center of higher education in the 1800s with the establishment of Furman Academy, the Greenville Baptist Female College, and the Southern Baptist Theological Seminary. Furman began in Edgefield (1827) and then moved to Winnsboro (1836), then Greenville (1851). The music building at the left of the bell tower and the entire campus can be seen in this 1901 city directory engraving. (Special Collections, Greenville County Library, Greenville.)

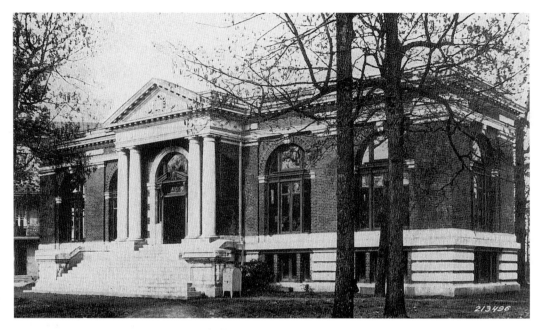

Trustees for Furman purchased lands for the University Ridge campus from Vardry McBee for approximately $3,750. In 1866, Furman Academy became Furman University. The Carnegie Library (seen here) and the Neblett Free Library (1897) were two of the first libraries in the region. (Special Collections, South Caroliniana Library, USC, Columbia; also, Special Collections, Furman University, Greenville.)

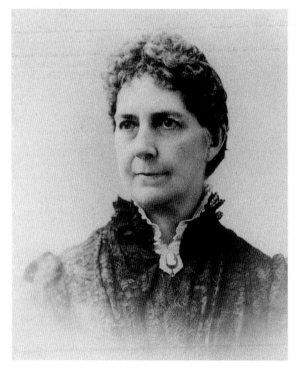

Mary Camilla Judson, lady principal of the Greenville Female College (1874–1910), was a practical feminist born in Connecticut. She had a superior education but had not been allowed to attend Yale. In 1894, she loaned the female college money from her life's savings to keep it going. It did, and she lived on campus until her death in 1920. In 1914, the Greenville Female College became the Greenville Woman's College in honor of Mary C. Judson. (Special Collections, Furman University, Greenville.)

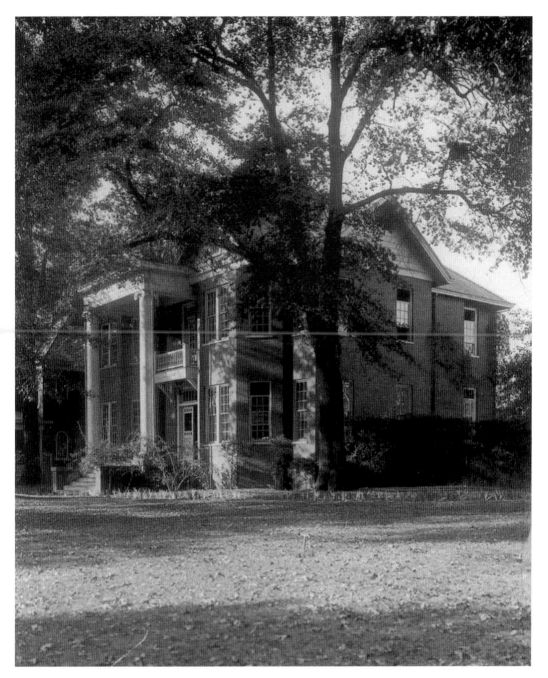

The Mary C. Judson Library (seen here) operated at the Greenville Baptist Female College. In 1897, Miss Judson formed the Thursday Afternoon Club, one of the first literary societies in Greenville. Soon other literary groups organized libraries including the Neblett Free Library. The Neblett Library, operated by Mrs. A. Viola Neblett, offered more than 3,000 books to the villagers. Most of the books were acquired by donations to the library. Beginning in 1924, African-American readers utilized a library at the Phillis Wheatley Association and Center, located on Broad Street. (Special Collections, Furman University, Greenville.)

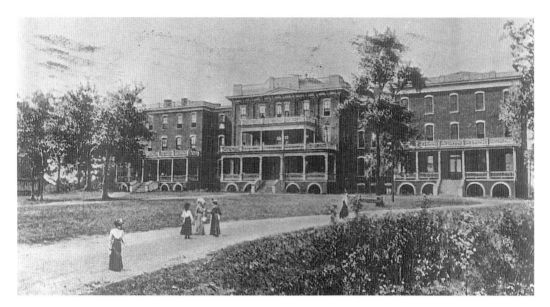

Established in 1854 by the South Carolina Baptist Convention, the Greenville Baptist Female College opened in 1856 on this site originally donated by Vardry McBee to the Greenville Academies. Presently, this College Street location is called Heritage Green, the cultural center of the county which features the Greenville County Main Library and the Greenville County Museum. In 1933, the female college merged with Furman University, and the college moved to a consolidated campus north of town. (Special Collections, Furman University, Greenville; also, Special Collections, South Caroliniana Library, USC, Columbia.)

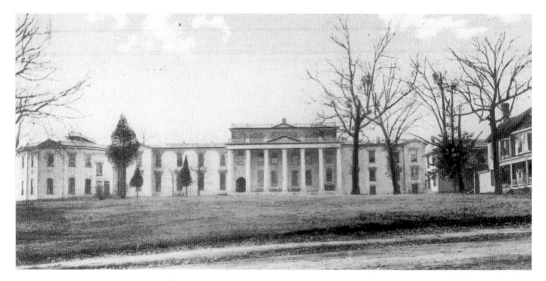

Owned by Vardry McBee's son, Alexander, McBee Terrace, or also known as McBee Hill, became the site of Chicora College, a Presbyterian school for women (built 1895). In 1915, the school relocated, and the Greenville campus buildings were sold. C.C. Good, the proprietor, remodeled Chicora into Colonial Apartments and the Colonial Theater. The facilities burned to the ground four years later, and the land was redeveloped for commercial use. (Special Collections, South Caroliniana Library, USC, Columbia.)

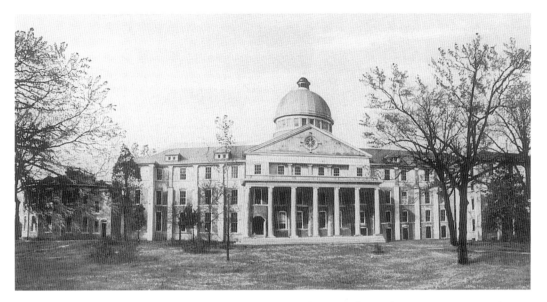

On the corner of South Main and Rhett Streets stood Chicora College. The 16-acre campus, with grounds landscaped down to the Reedy River's edge, also had a 1,200-seat auditorium. In 1915, Chicora merged with Queens College, presently located in Charlotte, North Carolina. (Special Collections, South Caroliniana Library, USC, Columbia.)

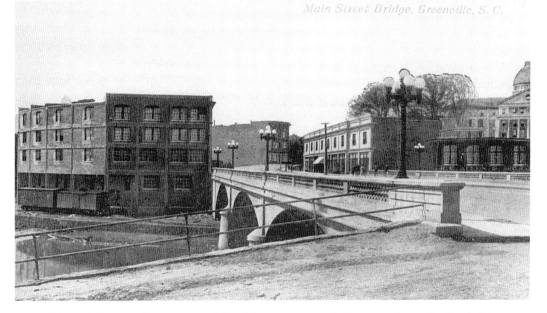

Chicora College can be seen at the right of the new concrete bridge erected over the Reedy River around 1911. A second bridge was erected on River Street, and 89 new arc streetlights were placed throughout the quaint town. (Special Collections, South Caroliniana Library, USC, Columbia.)

Built on Pendleton Street four years prior to the South Main Federal Post Office, Oaklawn School, or East End School, reflects Victorian Romanesque–styled architecture. At times, the school was called Central High School or later, Greenville High. (Special Collections, South Caroliniana Library, USC, Columbia.)

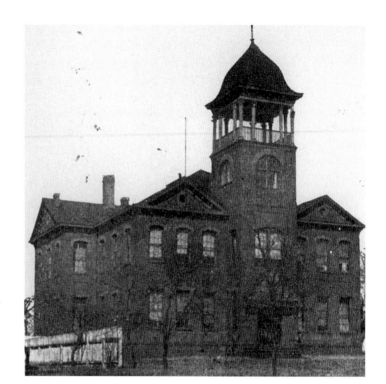

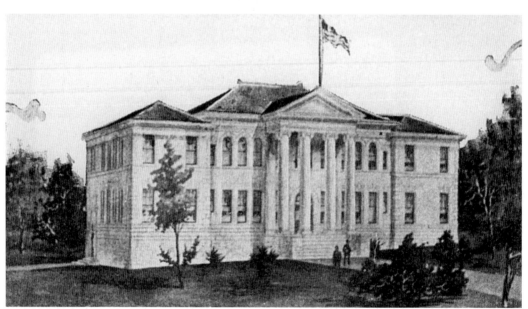

Children usually worked after sixth grade, so prior to World War I, each textile mill maintained its own elementary school. Then, in 1922, mill executives successfully petitioned the state to create Parker schools, named for mill welfare worker Thomas F. Parker. The district, one of the wealthiest in the state, contained 13 elementary schools and one high school. Parker schools' success and its educators received praise from *School and Society*, the *Readers' Digest*, *Textile World*, and *Look Magazine*. Park School is depicted above. (Special Collections, South Caroliniana Library, USC, Columbia.)

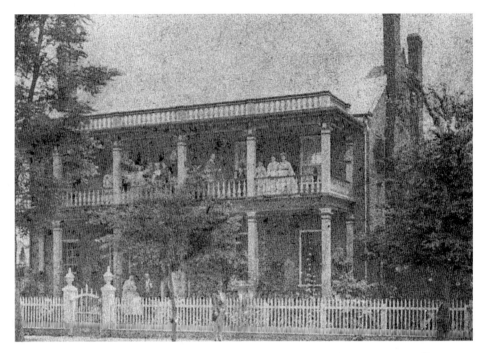

In the 1800s, Lowcountry architecture played an important role in influencing Greenville builders. The Cleveland Place is shaded by a long porch, the kind seen in Charleston homes. (Special Collections, South Caroliniana Library, USC, Columbia.)

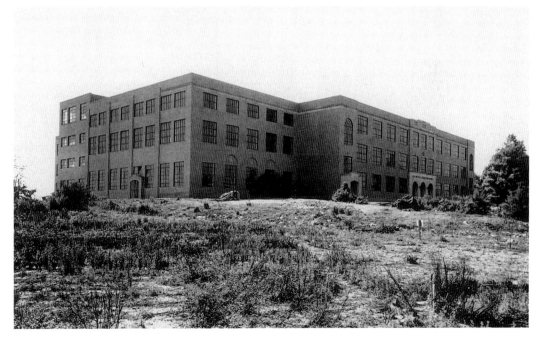

In 1936, Greenville High School was erected on the site of the Cleveland Place. (Special Collections, South Caroliniana Library, USC, Columbia.)

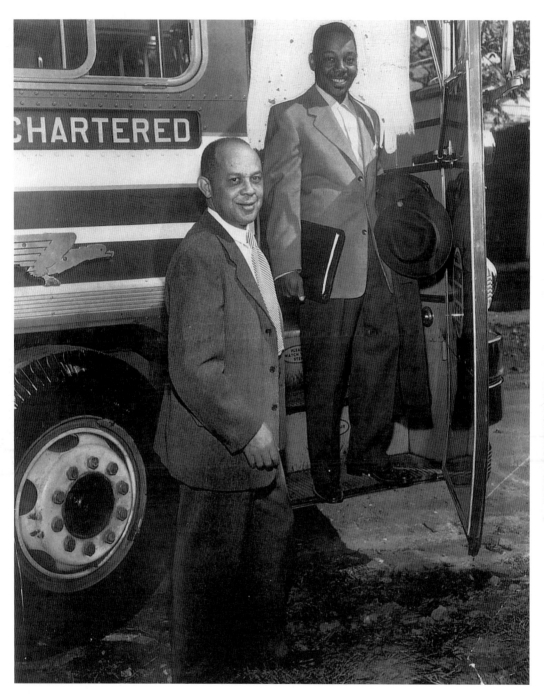

J.S. Beck (left), principal of Sterling, stands with fellow educator Wilfred Junius Walker Sr. Walker's awards for golf and tennis almost outnumber his civic accomplishments. He has been honored by the county council with the Greenville County Citizenship Award and the NAACP's 1992 Learning Is Priceless Award. Recently, Walker was inducted into the McKissick Museum's Broadcaster's Hall of Fame in Columbia. Walker was the first African-American sportscaster in the Southeast to conduct daily radio programs. (Courtesy of the Wilfred J. Walker Sr. family.)

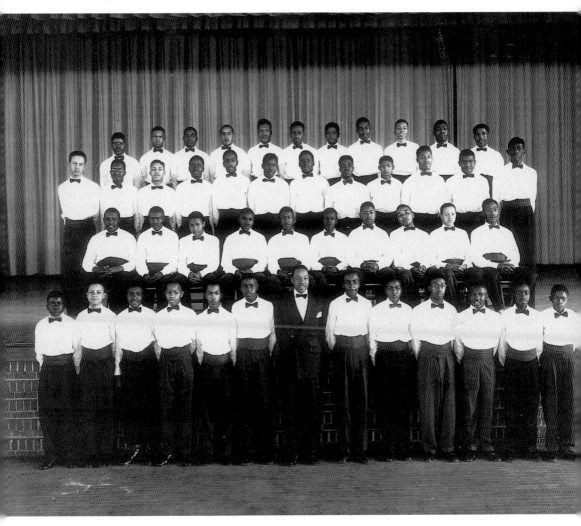

While at Hampton University in Virginia, Walker became assistant conductor of the Hampton Trade School Singers. In 1935, Wilfred J. Walker Sr. and the Hampton Trade School Singers entertained at a command performance at the White House for President Roosevelt and guests. Upon graduation from Hampton, Wilfred J. Walker Sr. began teaching math, English, drafting, and a variety of subjects at Sterling High. He served as an outstanding director of the Sterling High School Male Glee Club (pictured here), which won several state competitions. (Courtesy of the Wilfred J. Walker Sr. family.)

Bob Jones University moved to Greenville from Cleveland, Tennessee, and class began in the fall of 1947 on a 180-acre campus, squeezed between Pleasantburg Drive, Wade Hampton Boulevard, and East North Street. The university stands, without apology, for old-time religion and the absolute authority of the Bible. Its University Art Gallery and Museum is one of the most outstanding collections of European sacred art in the country. Billy Graham is probably one of the more well-known students.

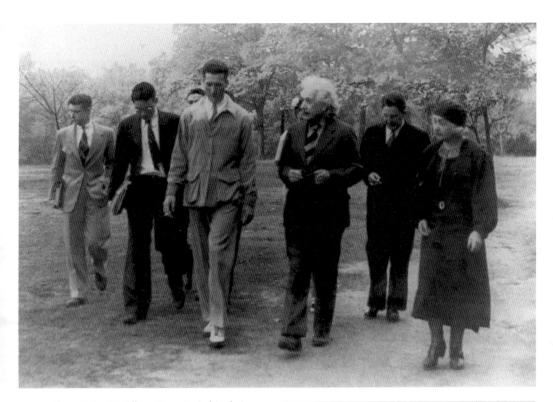

Above: Scientist Albert Einstein (white hair, center) strolls with Furman educators and students. Einstein had relatives, including a son, living in Greenville, and he frequently visited the area. (Special Collections, Furman University, Greenville.)

Right: Dr. George Washington Carver spoke to Furman students in 1923. Roland Hayes sang opera in the old Textile Hall, but throughout the majority of the twentieth century, blacks and whites lived and worked in separate environments. By the 1960s, the Civil Rights Movement was underway in the Upstate. Furman University embraced the changes by voluntarily admitting African Americans onto campus. In this view, Joe Vaughn (pictured here) addresses his classmates at a reunion. Vaughn was one of the first African Americans to receive a degree from Furman. (Special Collections, Furman University, Greenville.)

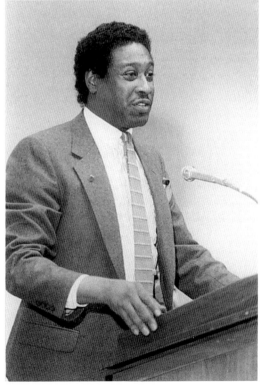

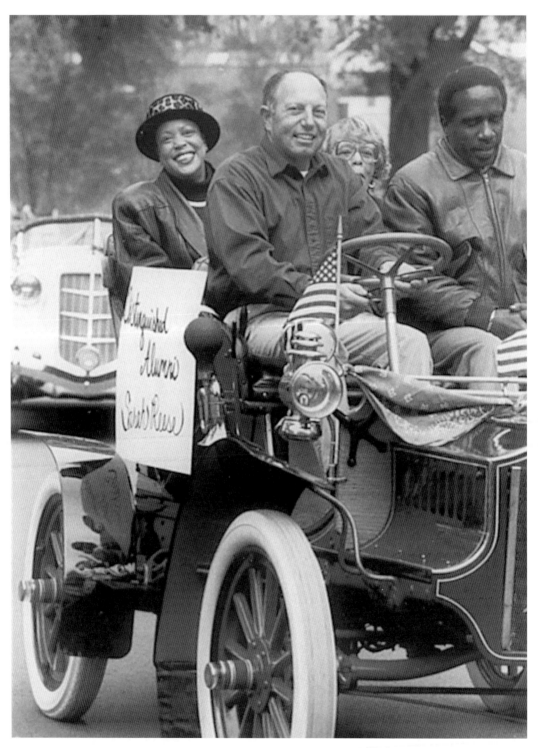

Sarah Reese, a professional opera singer, graduated from Furman in 1971 and later received the
Distinguished Alumni Award in 1992. (Special Collections, Furman University, Greenville.)

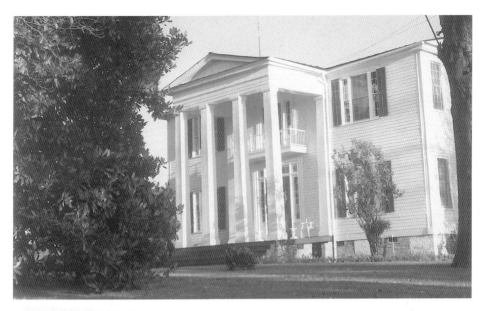

Built in 1857, Cherrydale eventually became the home of Eugene Stone III, founder of Stone Apparel. The beautiful structure was once the home of Furman University's president Dr. James C. Furman. Presently, Cherrydale is located on the Furman campus. (Marsh Collection, South Caroliniana Library, USC, Columbia.)

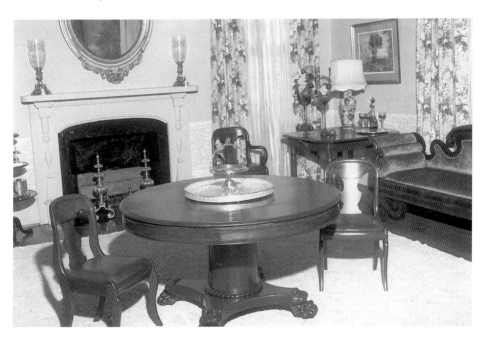

An interior view of Cherrydale (c. the early 1960s) reveals a home with much charm. Cherrydale belonged to George Washington Green in the 1840s and was purchased from him by Dr. James C. Furman in 1851, when James Furman became president of Furman Academy. (Academy Street is named after Furman Male Academy.) Eugene Stone III purchased the house and property from Furman's heirs in 1939. (Marsh Collection, South Caroliniana Library, USC, Columbia.)

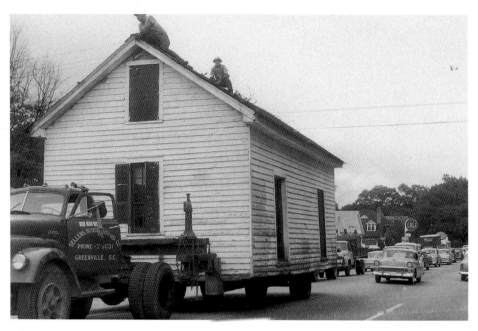

Prior to the completion of the University Ridge campus, this cottage and a room in the Tiddman House were utilized as the first Furman classroom facilities. The cottage was trucked to the new campus in the late 1950s. Men on the roof gently lifted cables, allowing the structure to move slowly down the Poinsett Highway. Recently, the Cherrydale House moved to the Furman Campus in like manner. (Special Collections, Furman University, Greenville.)

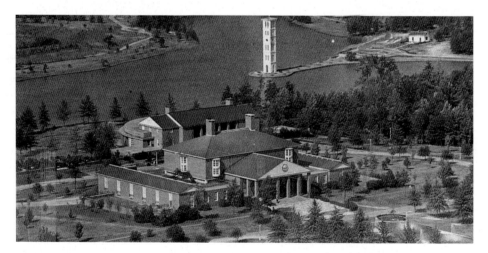

In 1950, Furman trustees purchased 973 acres near Travelers Rest. The architectural firm that had rebuilt Colonial Williamsburg was secured to create the new campus. The James Buchanan Duke Library, which houses the Southern Baptist Archives and Special Collections, is centered in a maze of seedlings and construction debris. In the distance is the replica of the first bell tower. To the right of the tower is the cottage where students first attended classes in Greenville in the 1850s. University Ridge structures, including Furman's original landmark tower, were razed in the 1960s to make way for a retail mall. Presently, the Bell Tower Mall houses Greenville County Social and Health Services offices. (Special Collections, Furman University, Greenville.)

three

From Textiles to Technology

At West Washington Street, this three-story warehouse housed the Piedmont and Northern Terminal. In November 1915, Greenville businessmen invited 169 exhibitors to this site for the first textile trade show. Because it was such a success, Greenvillians soon made plans to construct a permanent textile hall for future exhibits. (Special Collections, South Caroliniana Library, USC, Columbia.)

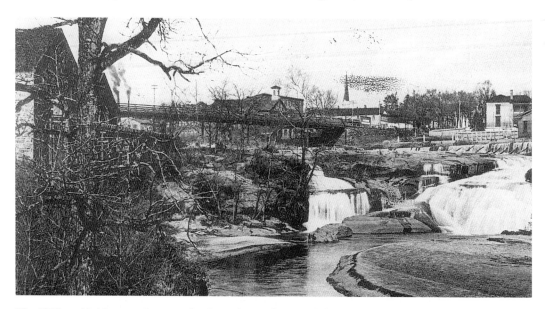

The 1889 steel bridge, a replacement for Gower's wooden one, linked South Main to present-day west Greenville. In the distance, the First Baptist Church steeple rises over the town while Reedy River feeds Vardry McBee's mills via the sluice seen on the left. Industries like the Gower, Cox, and Markley Carriage Factory began to crowd embankments where thickets of water grasses once flourished. (Special Collections, South Caroliniana Library, USC, Columbia.)

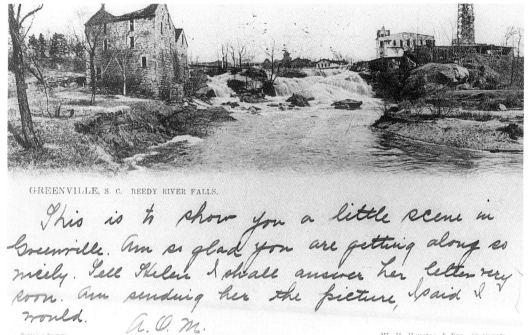

GREENVILLE, S. C. REEDY RIVER FALLS.

This is to show you a little scene in Greenville. Am so glad you are getting along so nicely. Tell Helen I shall answer her letter very soon. Am sending her the picture, I said I would.

A. O. M.

Printed in Germany. W. H. Houston & Bro., Stationers.

Above: After the Boston fire of 1871, Northern investors Oscar Sampson, George S. Hall, and George Putnam leased Vardry McBee's stone facilities as part of a new business venture. In 1873, this venture expanded, creating Camperdown Mills. Camperdown Mill No. 2 (at the right) manufactured yarns. Eventually, McBee's stone mill was razed and recycled into the Gassaway House, built in the 1920s. (Special Collections, South Caroliniana Library, USC, Columbia.)

Left: Industries began to grow in Greenville in the late 1890s. By 1907, business leaders expressed deep concern for the Reedy River and its polluted environment. City planning appeared on the public's agenda for the first time. Soon administrators solicited help from civic groups in organizing the first parks and recreation facilities. (Special Collections, South Caroliniana Library, USC, Columbia.)

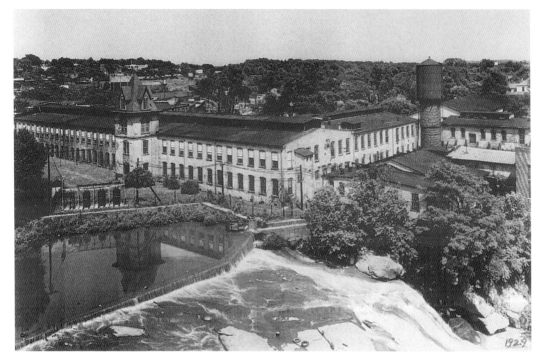

Camperdown Mills, Greenville's first post-bellum textile mill, produced yarn and gingham fabric until 1956. The building was razed to make way for contemporary structures, but the stone retaining walls and the anchor points of its dam are still visible above the falls at the Reedy River Falls Historic Park. (Courtesy of the Jim DeYoung family.)

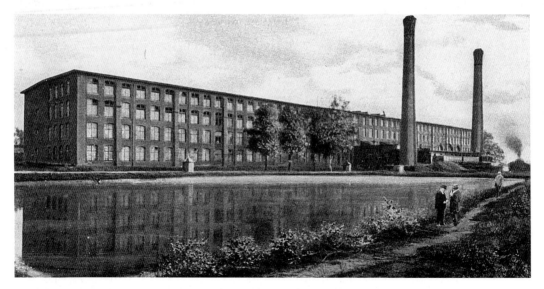

In 1895, the Francis W. Poe Manufacturing Company began operations. By 1915, the mill utilized more than 70,000 spindles and 1,700 looms. Poe employed between 900 and 1,000 people who lived in its mill village (population 2,500). While not the biggest mill in terms of physical size, Poe Mills was one of Greenville's most successful. (Special Collections, South Caroliniana Library, USC, Columbia.)

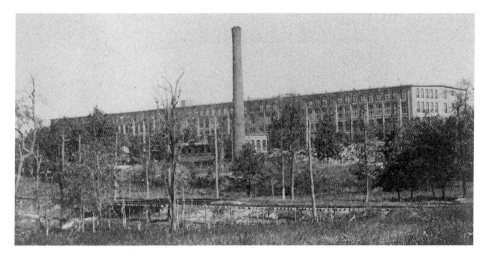

Brandon Mills, organized in 1899, suffered a strike in 1929. More than 1,200 workers walked out, resulting in a state-appointed legislative committee to investigate mill working conditions, the first of its kind in the South. Mill conditions soon improved. Brandon Mills is also remembered for one of its employees, a speedy 13-year-old boy named Joseph Jefferson Jackson (1888–1951). Jackson played baseball for Brandon Mills until 1907, when he joined the Greenville Spinners. With the Spinners, he gained the nickname "Shoeless Joe." In 1915, Shoeless Joe Jackson began playing for the Chicago White Sox. (Special Collections, South Caroliniana Library, USC, Columbia.)

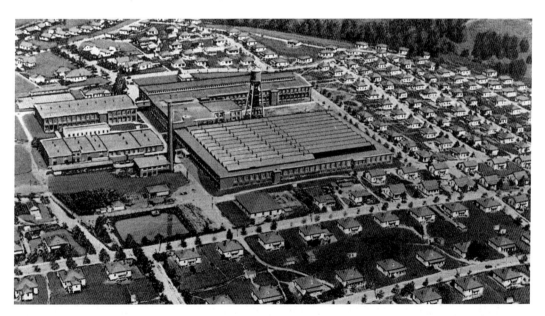

J.I. Westervelt organized Brandon Mills, then the Judson Mills about 1911. Judson Mills is named in honor of Dr. Charles. H. Judson, a Connecticut native who replaced James C. Furman as president of the Greenville Female College in 1864. Furman and its seminary closed during the Civil War, but the Female College struggled to remain open under the leadership of Judson. In 1893, Greenville Female College awarded the first Bachelor of Arts degree. The school flourished and eventually incorporated into Furman University. (Special Collections, South Caroliniana Library, USC, Columbia.)

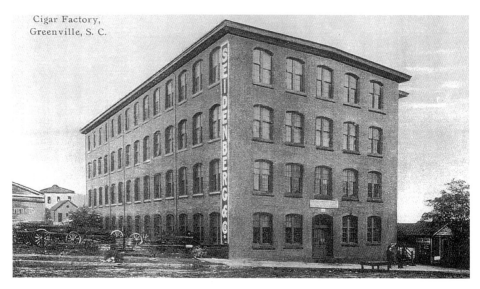

Cigar Factory,
Greenville, S. C.

As early as 1903, community leaders began to diversify Greenville's local economy. Their first effort became the American Cigar Company on Court Street behind the Liberty Life Building on Main. The cigar company, built on the site of Richard Pearis's home, produced approximately a half a million cigars per week, according to local historian Colonel Crittenden. Greenville also became headquarters for three insurance agencies and several banks including the Woodside National Bank. (Special Collections, South Caroliniana Library, USC, Columbia.)

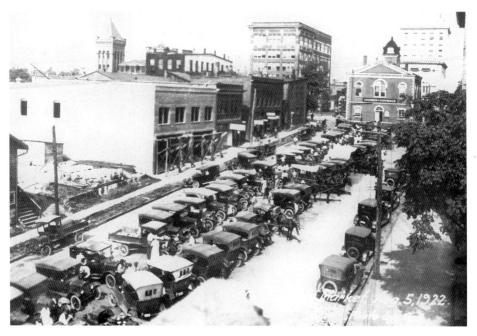

A curbside market existed behind the Old Record Building, which housed the chamber of commerce in the 1890s. Farmers came from around the Upcountry to present crops and crafts for the sale. (Special Collections, Greenville County Library, Greenville; also, the Jim DeYoung family.)

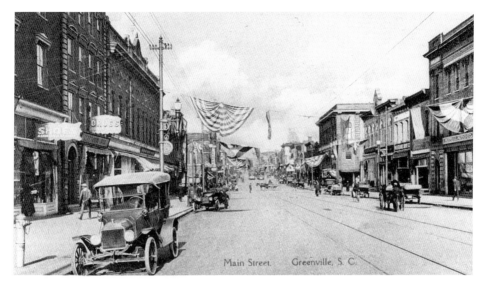

Carpenter Brothers' Drug Store No. 1, c. 1919, appears at the left in this photographic postcard. Located next to the Mansion House, No. 1 proved most profitable during court days. The brothers also ran four other drugstores in Greenville, including the Ottaray Drug Store. In 1925, the brothers relocated No. 1 across the street. This drugstore, a fixture in downtown, still does business at this location. (Special Collections, South Caroliniana Library, USC, Columbia.)

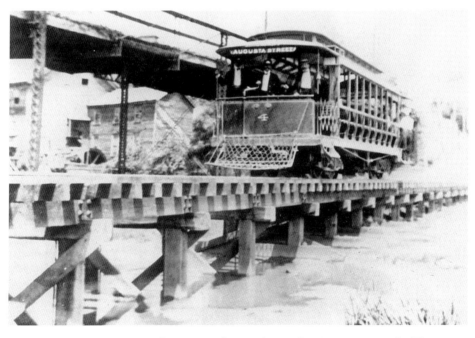

In this view, Augusta Street Trolley No. 4 rolls over the Reedy River on new tracks. The carriage factory is visible at the left. (Special Collections, Greenville County Library, Greenville; also, courtesy of the Jim DeYoung family.)

Bergamo, Italy, became the sister city of Greenville in the early 1980s, and Bergamo also became a showpiece on Main. This is the Bergamo building c. 1930s. (Courtesy of the Jim DeYoung family.)

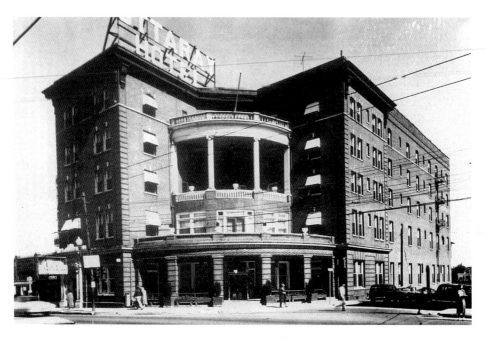

Demolished in 1960, the Ottaray Hotel opened in June 1909. The five-story, red-brick structure was erected at an angle at the highest point in the city. The hotel faced the corner of Main and Oak Street. Presently, the Greenville Commons Building and the Hyatt Hotel operate on the land where the Ottaray Hotel once stood. (Special Collections, South Caroliniana Library; also, courtesy of the Jim DeYoung family.)

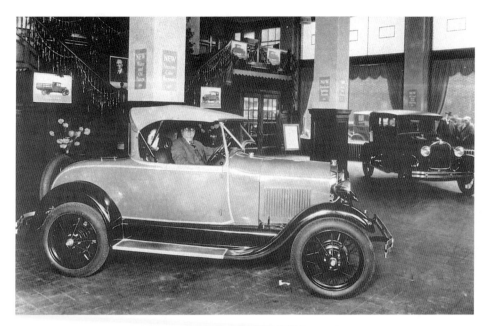

Here, Greenvillians stare through a big window to get a glimpse at the latest in Detroit technology. The automobile made travel to the Possum Kingdom, the area in the southern-most parts of the county, and the Dark Corner, the northern hill lands of the county, a real treat for the new, growing middle class. (Courtesy of the Jim DeYoung family.)

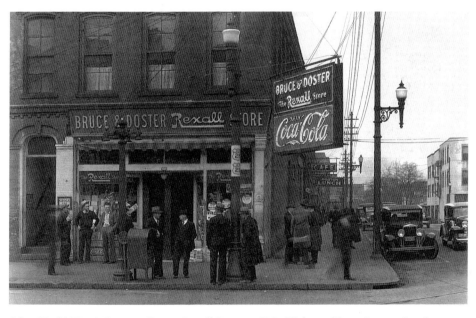

After World War I, Bruce & Doster Rexall Store on U.S. Highway 25, or Augusta Road, became a meeting place for mill managers, businessmen, and bankers. The drugstore featured informative newspapers and magazines from around the world, a big plus for Upstate men with a mind for career mobility and financial advancement. (Courtesy of the Jim DeYoung family.)

Corner Lawrence and Buncombe St
Greenville, S. Car.

FIRE DEPARTMENT

Macabee Street,
looking East,
Greenville, S. Car.

Two photos merge to create this interesting postcard of 1918. Soldiers stationed at Camp Sevier sent images like this to their families. The cards reassured parents and loved ones that the young men lived near a safe, wholesome community. (Special Collections, South Caroliniana Library, USC, Columbia.)

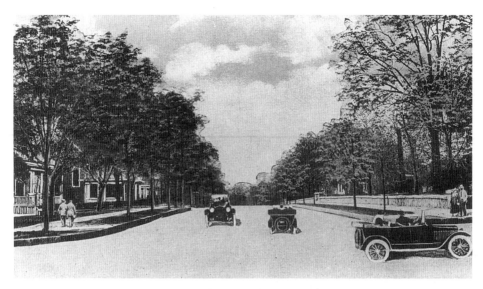

Streets were first named for destinations like Buncombe, North Carolina; Augusta, Georgia; or Laurens, South Carolina. Other avenues were named for prominent property owners such as Earle, McBee, and Stone. Some roads were named for Baptist ministers. Broadus Avenue (shown here) was named for John A. Broadus, a writer of religious tracts during and after the Civil War. With preacher Basil Manly, Broadus made Greenville a small, publishing center for Baptist materials. In fact, the first syllables of the names Broadus and Manly were permanently combined to create Broadman Press, a Baptist publisher, and the Broadman hymnal book, which contains classic songs like "Amazing Grace." (Special Collections, South Caroliniana Library, USC, Columbia.)

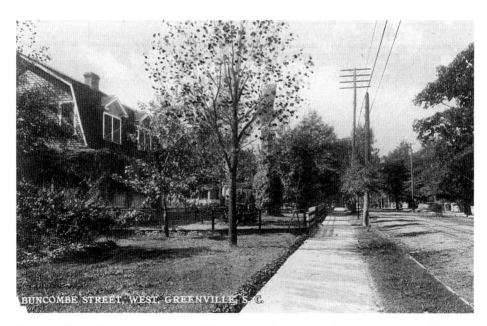

Houses and trees lined the clay streets of West Buncombe in the early 1900s. (Special Collections, South Caroliniana Library, USC, Columbia.)

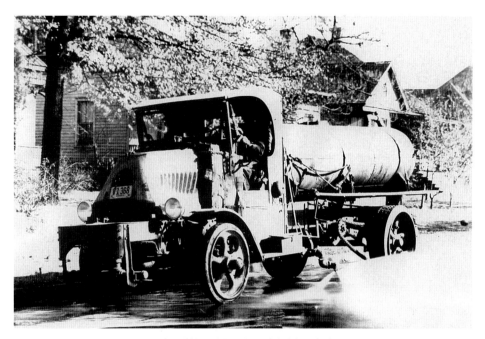

In 1910, Greenville approved a $300,000 bond issued for permanent improvements. By 1912, Main Street and all its side streets were paved. By 1918, two national highway systems—the east-west Bankhead Highway and the north-south Dixie Highway—ran through the city and county, and the Greenville-Hendersonville Highway had opened. Street-cleaning trucks quickly became a common sight. (Courtesy of the Jim DeYoung family.)

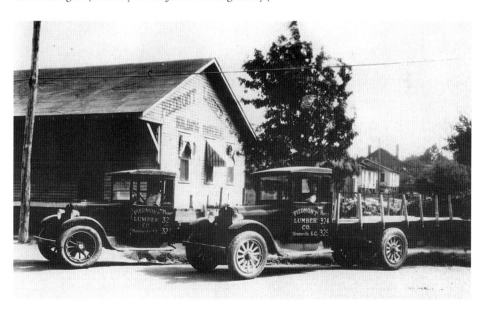

While the city grew, the mill villages expanded into modern suburbs. Piedmont Lumber Company, located at 25 Montgomery Avenue at Pinkney, provided delivery to these mill areas. Such local services expedited construction and helped contractors meet very tight schedules. (Courtesy of the Jim DeYoung family.)

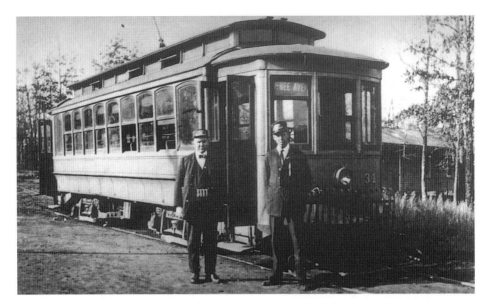

Trolleys such as No. 31 became a part of the past when city transportation modernized in 1937. Duke Power Company announced that old streetcars would be replaced by buses or trackless trolleys. The new system took six months to install at the approximated price of $135,000. The system also expanded services farther out Park Place, East McBee Avenue, and East Washington Street. (Courtesy of the Jim DeYoung family.)

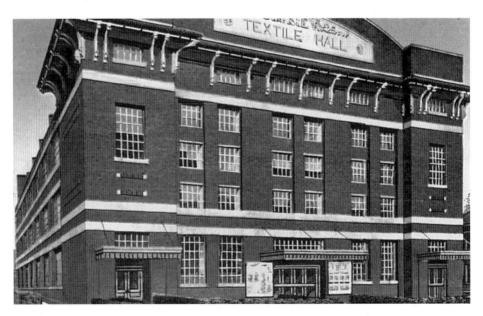

Greenville's first textile show was held in a warehouse. In 1917, Textile Hall opened on West Washington Street. Textile Hall was designed by Joseph Emory Sirrine (1872–1947), a Furman graduate for whom the bell tolled upon his death. In his lifetime, Sirrine engineered projects including 64 mills, 22 mill additions, and additions to Camp Sevier, Fort Bragg, and, later, The Citadel. He also designed Sirrine Stadium, which still stands. Textile Hall was razed in the 1980s. (Special Collections, South Caroliniana Library, USC, Columbia.)

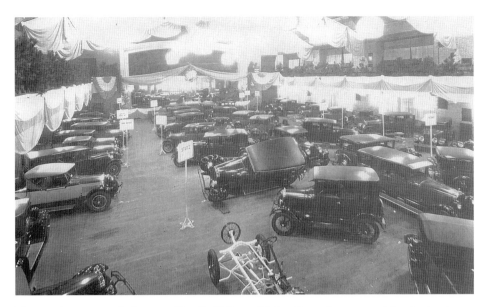

The newly constructed, five-story Textile Hall was filled with modern automobiles. At the time, the region's population soared to 1 million within 100 miles of the downtown facility. Greenville led the state in commerce with Textile Hall as its centerpiece of presentation for not only weaving and dying apparatus, but the best of the twentieth-century inventions and scientific gadgets. (Courtesy of the Jim DeYoung family.)

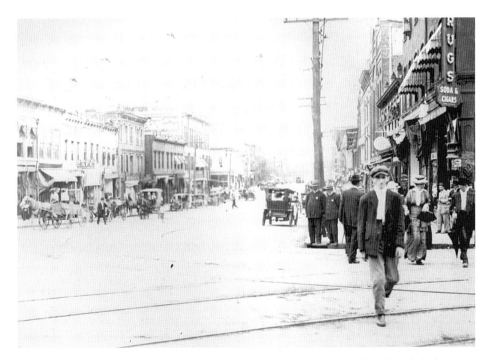

At the left in this *c.* 1920s photograph are Main Street buildings that would be demolished to make way for the Carolina's tallest building, the Woodside Building. (Special Collections, Greenville County Library, Greenville; also, courtesy of the Jim DeYoung family.)

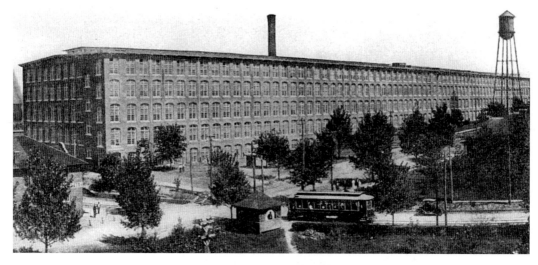

Born in Greenville County, the Woodside brothers—Edward F. Woodside, J. David Woodside, Robert I. Woodside, and John T. Woodside—worked together to build the Woodside Cotton Mill (1902). The mill's success allowed the brothers to organize the Greenville Community Hotel Corporation, which financed the $1.5 million Poinsett Hotel on Main Street. (Special Collections, South Caroliniana Library, USC, Columbia.)

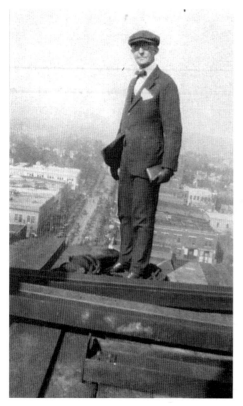

J. Ed Hart, a member of Greenville's Public Works Commission, took this *c.* 1921 snapshot of G.H. Gilbert, supervising architect associated with designers Nowbray & Uffinger of New York. Gilbert stands on the skeletal 14th floor of the Woodside Building. Mule teams on Main Street below transported materials to the worksite while New York steel workers from the Charles T. Willis Firm assembled them. (Courtesy of Jason H. Woodside and the Greenville County Library, Greenville.)

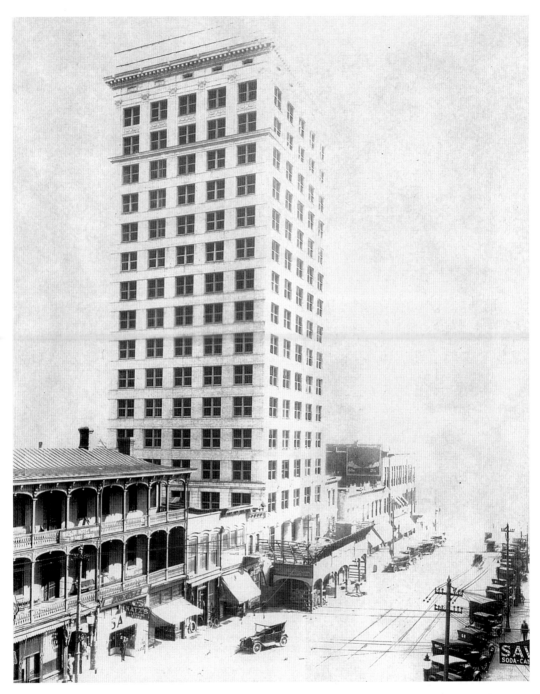

The Goodlett Building, with its beautiful arched porches, is dwarfed by the nearly completed Woodside Building, a 17-story wonder that established office spaces with breathtaking views of the mountains as a real estate premium. The Woodside Building (built 1923, razed 1975) also sparked investors to seriously consider Greenville as a commercial address for modern department stores and franchises. In March 1924, William H. Belk and William D. Simpson opened Belk-Simpson. Department stores began to reshape Main Street and Greenville. (Courtesy of the Jim DeYoung family.)

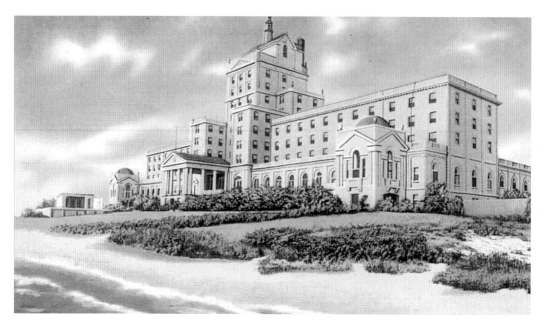

In 1926, John T. Woodside (1864–1946) invested in 66,000 acres surrounding Myrtle Beach. From 1924 to 1928, Woodside directed the construction of professional golf courses and paved highways. In 1927, Woodside announced the construction of Ocean Forest Hotel (shown here). He had planned to open another exclusive resort in 1929, but the stock market crashed. The Great Depression dissolved the Woodside brothers holdings. Myrtle Beach properties were sold to locals at bargain rates.

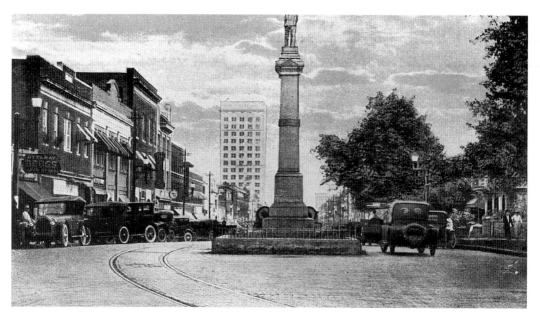

The Woodside Building dominated Main from 1924 until 1962, when the Daniel high-rise was constructed. At the right of this view are the remnants of Greenville's older residential houses. The 200 block of Main had grown substantially, and by 1948, Main Street had lost all of its residential housing. (Special Collections, South Caroliniana Library, USC, Columbia.)

When the stock market crashed, the Woodside empire collapsed. The Myrtle Beach properties, with their million-dollar improvements, were sold to Horry County businessmen at bargain rates. John T. Woodside moved from a Crescent Avenue house to this one on East Washington Street. At the right of the Woodside House is the Fourth Presbyterian Church, which still stands. (Special Collections, South Caroliniana Library, USC, Columbia.)

This new post office building on the corner of East Washington and Church Streets opened on September 27, 1937. It was a part of projects brought about by the Federal Emergency Relief Administration and the Public Works Administration of the Great Depression era. Presently, the building is known as the Clement F. Haynsworth Jr. Federal Building. (Courtesy of the Jim DeYoung family.)

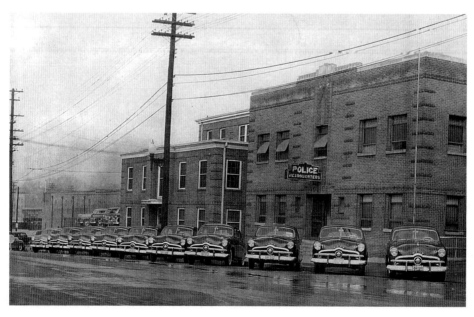

Ten sleek, new Ford squad cars face Broad Street in front of the police headquarters. Throughout its history, Greenville's crime rate has been relatively low for the South. (Courtesy of the Jim DeYoung family.)

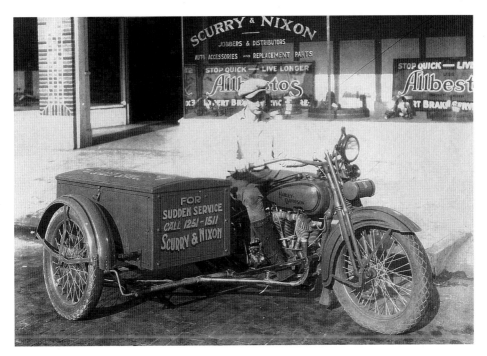

Motor bikes, such as this Harley Davidson with a flathead engine, could master mud as well as cobblestones, making Scurry & Nixon one of the more reliable auto and farm machinery repair groups in the county. (Courtesy of Jim DeYoung family.)

C & WC railway depot was located on Falls Street, which led to the Reedy River. The C & WC was near the Old Town Spring, a place where the villagers once gathered their drinking water. (Special Collections, South Caroliniana Library, USC, Columbia.)

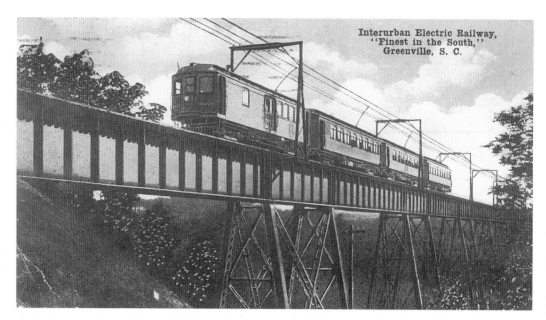

Trolleys and trains began to tie the city to new suburbs and villages. In 1911, approximately 17 miles of Greenville could be reached via the "Interurban Electric Railway." The beltline of this system encompassed all the mills, Pendleton Street, West Greenville, College Street, and Main. When the Woodside brothers developed the Overbrook area, the trolley line extended into East North Street, across a bridge at Richland Creek. (Special Collections, South Caroliniana Library, USC, Columbia.)

County residents dreamed of a railroad that would connect Greenville to Asheville, so the Carolina, Knoxville & Western Railway Company formed in 1887. Tracks were laid from Greenville north along the banks of the Reedy River. In 1892, they reached Marietta, but by 1902, the tracks went no farther than the community of River Falls. The short line of tracks was nicknamed the Swamp Rabbit. This view is the last of Swamp Rabbit. (Marsh Collections, South Caroliniana Library, USC, Columbia.)

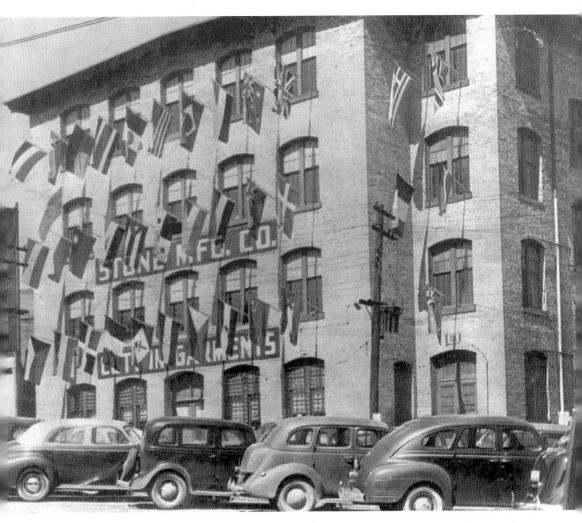

Eugene E. Stone III founded Stone Manufacturing in a loft on River Street in 1933. He began with eight employees and five sewing machines. Stone designed bloomers, dresses, slips, and sleepwear. Stone expanded in 1942 into the Seidenberg & Company, or the American Cigar Factory building. It was frequently called the Court Street Apparel Manufacturing Plant. In 1951, the Cherrydale plant opened, and by 1980, Stone Apparel had regional offices in Dallas, Chicago, Miami, Los Angeles, Atlanta, and New York. (Courtesy of the Jim DeYoung family.)

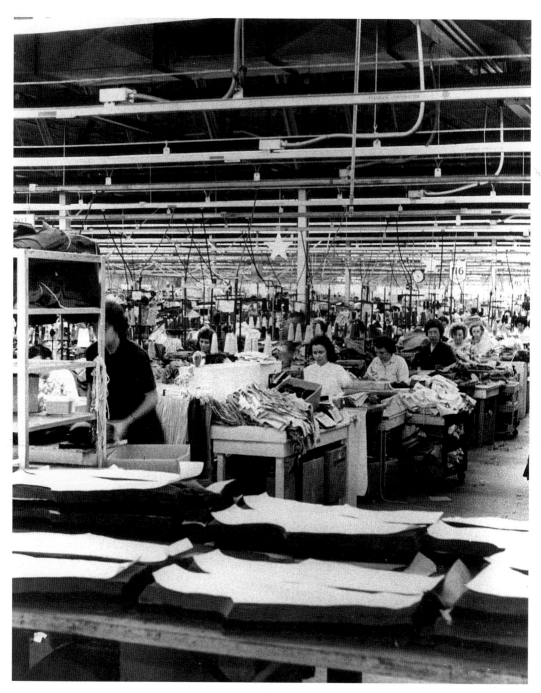

About 2,000 sewing machines operated in this airy room to produce Stone garments. The Cherrydale Plant (erected 1951) had cutting tables as long as football fields. They accommodated over 300 miles of cloth. Electric cutting knives could cut, at one time, through 600 layers of cloth. At the time, the Cherrydale Plant was the world's largest sewing room under one roof with 2,000 sewing machines. The Cherrydale Plant occupied 7 acres. Presently, a retail/shopping district occupies the site of the Cherrydale Plant. (Marsh Collections, South Caroliniana Library, USC, Columbia.)

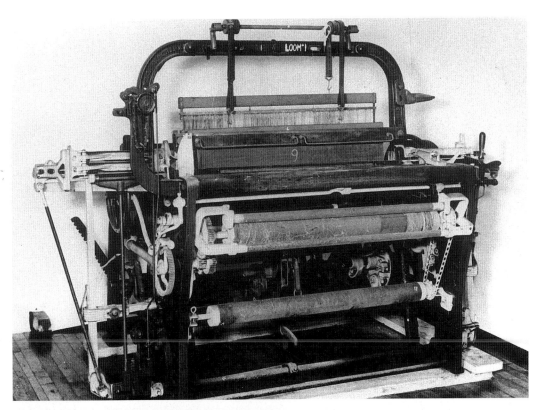

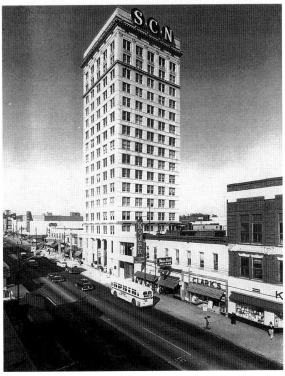

Above: In this *c.* 1960s photograph, J.P. Stevens Loom #1 stands idle in a corner. Soon, computers would be introduced into businesses. (Marsh Collections, South Caroliniana Library, USC, Columbia.)

Left: In the 1950s, the Census Bureau declared Greenville a metropolitan area. Main Street grew into four lanes. Suburban shopping malls were under construction. Lewis Plaza (built 1948) on Augusta Street, which was annexed into the city in 1946, was the first to open. Wade Hampton Mall opened in 1962, and then McAlister Square at Pleasantburg Drive opened in 1965. By 1967, many of the stores along Main had relocated to the malls. Downtown rapidly declined as the center of the city and the county. (Courtesy of the Jim DeYoung family.)

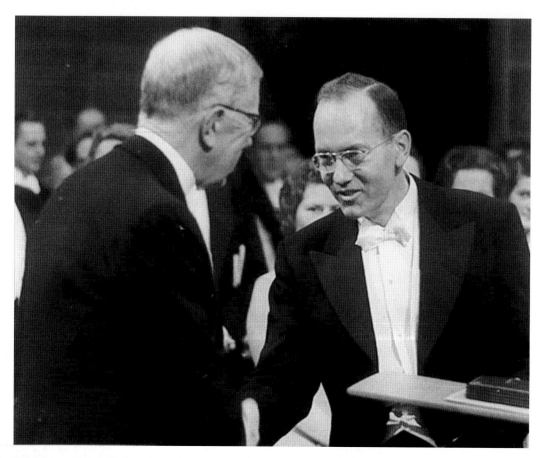

Raised on a Greenville farm on Sumner Street, Charles Hard Townes (born 1915) won the 1964 Nobel Prize in physics. He shared the prize with two Russian scientists for the invention of the maser (Microwave Amplification by Stimulated Emission of Radiation) and the laser. These inventions ultimately made satellite communications possible. In 1951, with research conducted jointly with Arthur Schawlaw, another distinguished physicist and Townes's brother-in-law, Townes patented a concept that led to the construction of the world's first successful optical maser, or laser. C.H. Townes entered Furman in 1931, where he received a B.A., then B.S. degree in physics. He continued his education at Duke University, then at the California Institute of Technology. During World War II, Townes helped perfect radar and radar bombing. After the war, he worked at Bell Telephone Laboratory, where he investigated microwave spectroscopy and absorption. Townes has received many honors including induction into the Science Hall of Fame. He is the one Greenvillian whose accomplishments have greatly impacted the entire world. (Special Collections, Furman University, Greenville.)

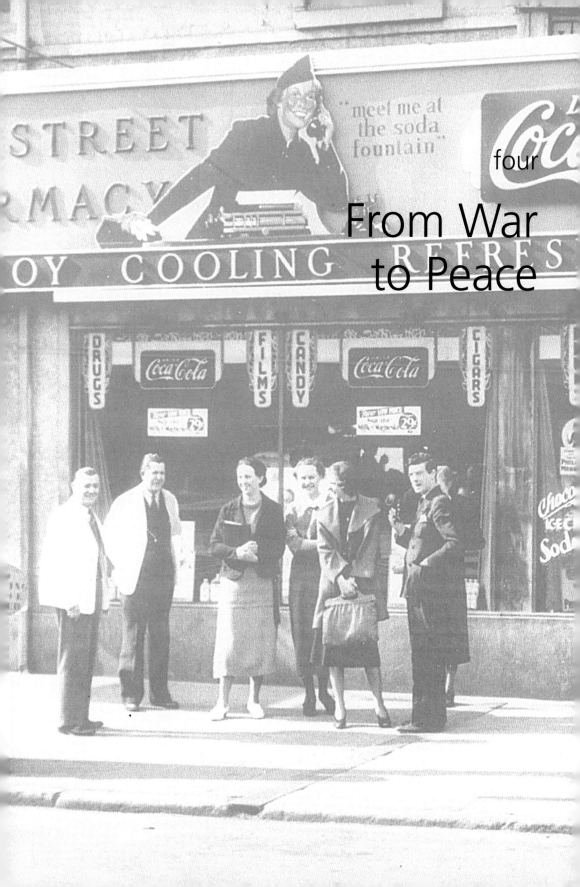

four

From War
to Peace

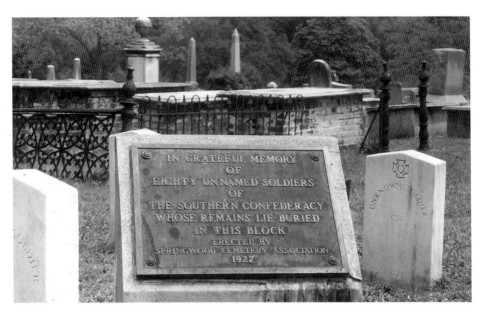

Chancellor Waddy Thompson owned the house and gardens that would become Springwood Cemetery. The cemetery was deeded to the district in 1829. It is the resting site for many Tories, Patriots, and Confederates, although many of Greenville's founders rest in local churchyards. (Photo by P.E. Peters.)

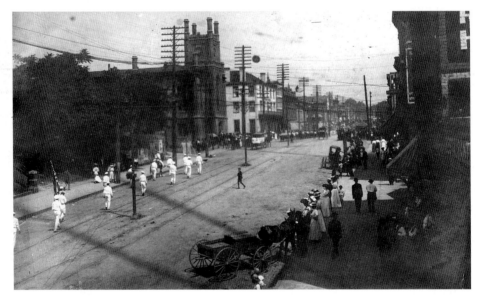

Congress declared war on Spain after the battleship *Maine* sank in Havana Harbor, Cuba, in 1898. The Butler Guards, part of the South Carolina National Guard, was the only active Greenville military unit at the time. Quickly, a second company, known as the Greenville Guards and the Greenville Volunteers, organized. They left by train for Columbia. The troops went as far as Camp Cuba Libre, Florida, and by then, the war had ended. The church-like structure in this view is the third courthouse (built 1855). (Courtesy of the Jim DeYoung family and the Greenville County Library.)

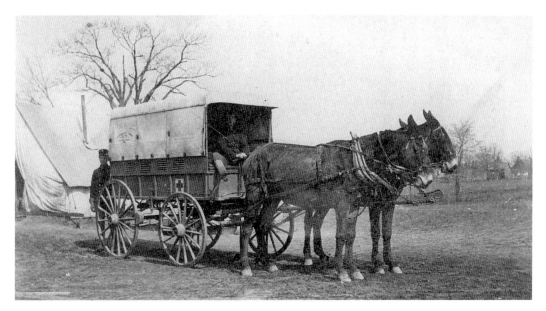

A soldiers' ambulance rig, one of the first in Greenville, served Camp Wetherill. (C.L. Bailey Collections, Schomburg Center for Research in Black Culture, New York Public Library.)

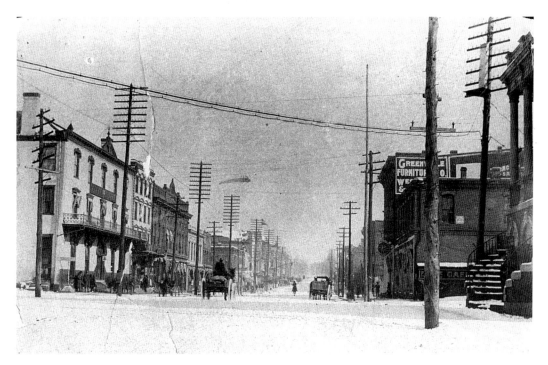

During the Spanish-American War, northern troops stationed at Camp Wetherill complained about Greenville's cold weather. Here, in this 1890s view, a wagon rolls through the snow, past the Mansion House on the left. The old Record Building's portico and semi-circular steps are visible on the right. A horseman in the center of the image rides toward the Confederate Monument, a ghost at the residential end of North Main. (Special Collections, South Caroliniana Library, USC, Columbia.)

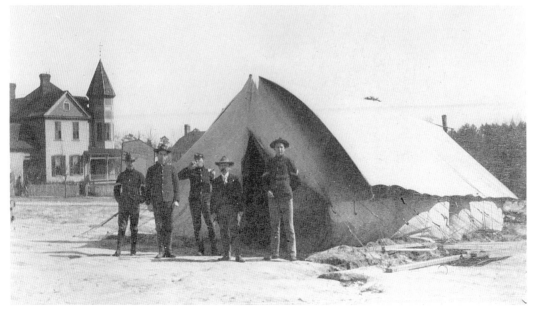

Above. About 10,000 men were stationed at Wetherill. By 1914, African-American citizens resided in space occupied by Camp Wetherill and the Second Brigade. Eventually, this area became the location of Sterling High School, an educational center for African Americans until the late 1960s. Camp Wetherill closed in 1899. Pictured here are a few soldiers and a view of the canteen and officers' mess camp. (C.L. Bailey Collections, Schomburg Center for Research in Black Culture, New York Public Library.)

Right: Camp Wetherill, an army training camp, had a great impact on Greenville in 1898. Named for Captain Alexander M. Wetherill, one of the first soldiers to die at San Juan Hill, Camp Wetherill was located north of Earle Street between Buncombe Street and present-day Wade Hampton Boulevard. Whitehall served as a nurses' home, and the campgrounds extended farther south stretching beyond Mills Mill, near the site of the Greenville General Hospital. The huge camp trained many troops including the 203rd New York Volunteer Infantry on parade in this view photographed by C.L. Bailey. (Schomburg Center for Research in Black Culture, New York Public Library.)

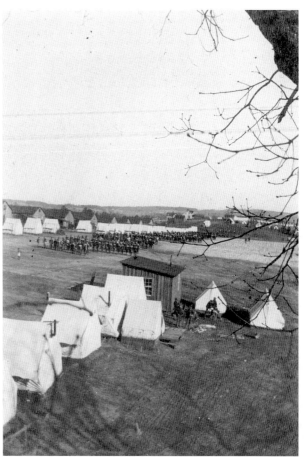

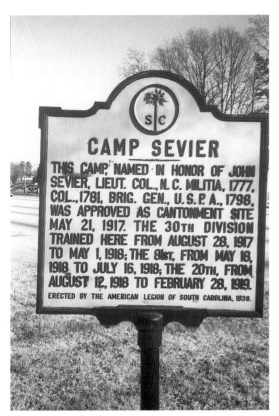

CAMP SEVIER

THIS CAMP, NAMED IN HONOR OF JOHN SEVIER, LIEUT. COL., N. C. MILITIA, 1777, COL.,1781, BRIG. GEN., U.S.P.A., 1798, WAS APPROVED AS CANTONMENT SITE MAY 21, 1917. THE 30TH DIVISION TRAINED HERE FROM AUGUST 28, 1917 TO MAY 1, 1918; THE 81ST, FROM MAY 18, 1918 TO JULY 16, 1918; THE 20TH, FROM AUGUST 12, 1918 TO FEBRUARY 28, 1919. ERECTED BY THE AMERICAN LEGION OF SOUTH CAROLINA, 1938.

Left: General Leonard Wood was a fast friend of Captain W.G. Sirrine of Greenville. The two served together in Cuba during the Spanish-American War. Sirrine brought General Wood to Greenville, and this visit helped make Camp Sevier possible. This marker is located between Taylors and the City of Greenville on Old US 29, or Wade Hampton Boulevard. (Photo by P.E. Peters.)

Below: Encouraged by the success of Camp Wetherill during the Spanish-American War, local businessmen lobbied the War Department in 1917 and secured a cantonment that became Camp Sevier. The hastily constructed tent grounds began 5 miles from the city and filled more than 1,800 acres surrounding Rutherford Road and Wade Hampton Boulevard. Railroad tracks also ran through the area, making mobilization of the forces both practical and efficient. (Special Collections, South Caroliniana Library, USC, Columbia.)

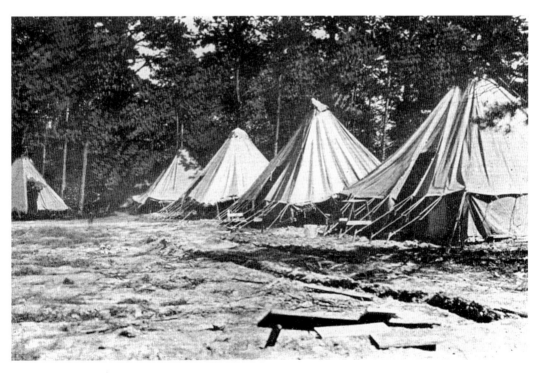

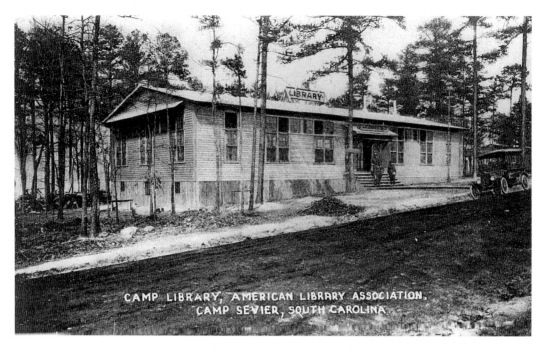

CAMP LIBRARY, AMERICAN LIBRARY ASSOCIATION,
CAMP SEVIER, SOUTH CAROLINA.

Camp Sevier had a library and one of the first hospitals in the region. Camp Sevier also stimulated a building boom with city infrastructure systems, such as water and sewer, expanding into the northeast portion of the county. (Special Collections, South Caroliniana Library, USC, Columbia.)

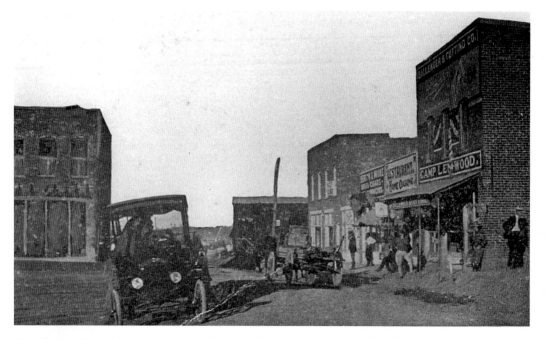

A small "town" developed within Camp Sevier. Gay Paris offered soldiers fresh cigars from Mr. B. Moore, home-cooked meals from the restaurant, and haircuts at the Camp Lenwood building. (Special Collections, South Caroliniana Library, USC, Columbia.)

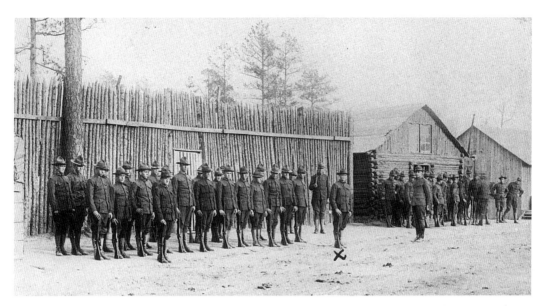

Sergeant George Haughter inked an "X" beneath his feet so that he could be easily identified by his family in this black-and-white postcard. By the time Haughter sent the card to his folks, Camp Sevier had developed into more than a tent city. It consisted of 6 YMCA buildings, 50 mess halls, a library, a hospital, a printing office, a large bakery, and numerous businesses. More than 27,000 men from Louisiana to Massachusetts were trained at the camp. Women nurses also worked at Camp Sevier. (Charles E. Hill Collections, South Caroliniana Library, USC, Columbia.)

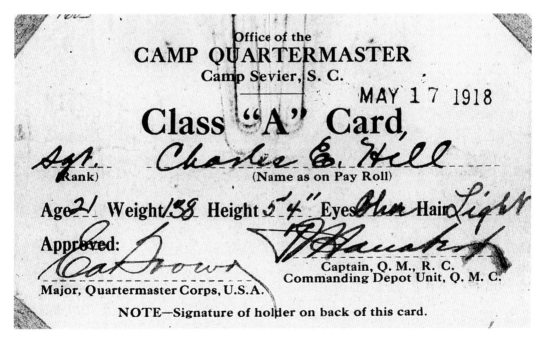

Sergeant Charles E. Hill, who served at Camp Sevier, obtained his Class "A" Card on May 17, 1918. When he could travel, he would drive into the city and county and photograph the scenes for his scrapbook. (Charles E. Hill Collections, South Caroliniana Library, USC, Columbia.)

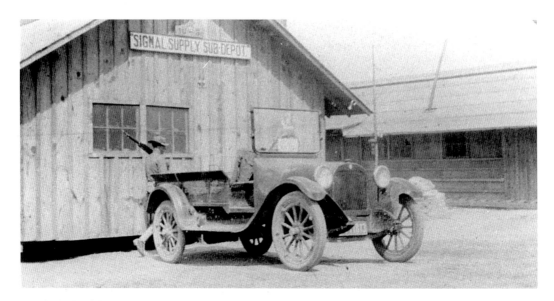

On the back of this image, Sergeant Charles Hill scrawled, "My truck in front of the depot." Young Hill was behind a camera so much that his physical appearance would not be known if it were not for his Class "A" Card, which he kept in his scrapbook. (Charles E. Hill Collections, South Caroliniana Library, USC, Columbia.)

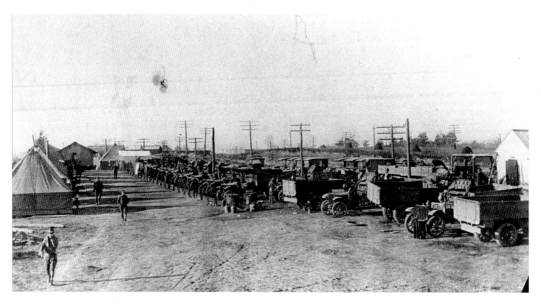

Above: In this photo, the 787th motorized truck company, a supply force, sits idle at Camp Sevier in Greenville. The 787th was trained to quickly deliver men, food, or ammunition to the front lines of Europe during World War I. (Charles E. Hill Collections, South Caroliniana Library, USC, Columbia.)

Opposite below: Soldiers are seen here working on a jalopy at the truck company's shop at Camp Sevier. According to Sergeant Charles Hill's notes, vehicles seldom broke down mechanically. Tire maintenance, however, proved more difficult. In April 1918, the concrete highway linking Sevier to Greenville was completed. (Charles E. Hill Collection, South Caroliniana Library, USC, Columbia.)

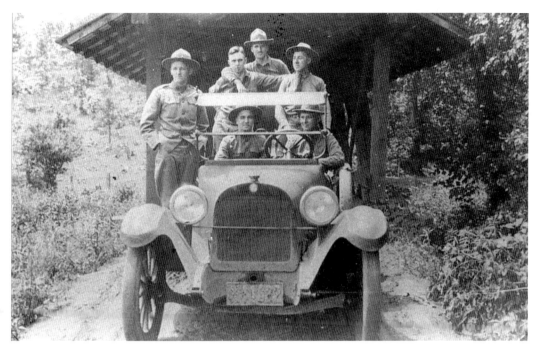

Above: Sergeant Charles Hill and his buddies were sight-seeing in a modern war machine, the automobile. Hill writes that he visited the Reedy River. He also documented soldiers swimming at Chick Springs, located 3 miles northeast of Camp Sevier. (Charles E. Hill Collections, South Caroliniana Library, USC, Columbia.)

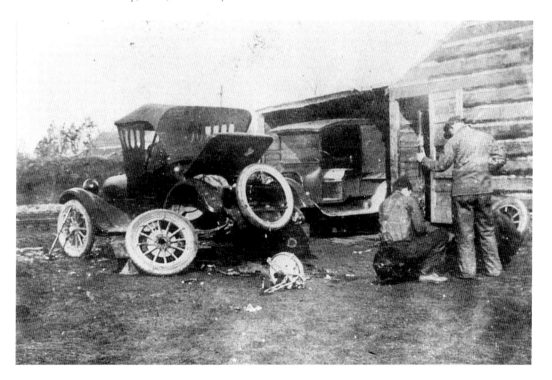

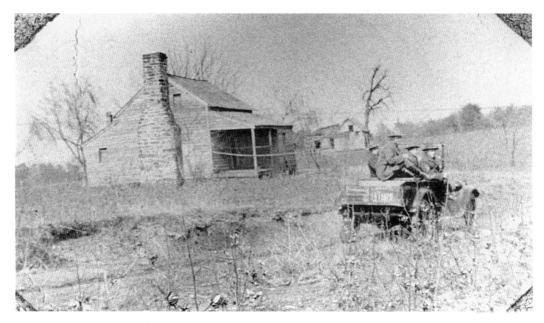

On one of his sightseeing adventures, Sergeant Charles Hill photographed two Greenville homes belonging to African-American families. The truck and Hill's buddies sit in a small cotton field that has been harvested for the year. (Charles E. Hill Collection, South Caroliniana Library, USC, Columbia.)

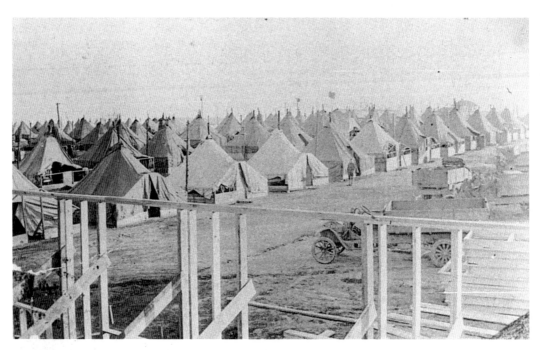

In the fall of 1918, residents of Greenville and Camp Sevier suffered from Spanish influenza. The tent city was put under quarantine, but 45 men died with more than 1,000 cases of flu reported. World War I ended on November 11, 1918, about 13 days after the quarantine ended. By March 1918, Camp Sevier had closed. (Charles E. Hill Collection, South Caroliniana Library, USC, Columbia.)

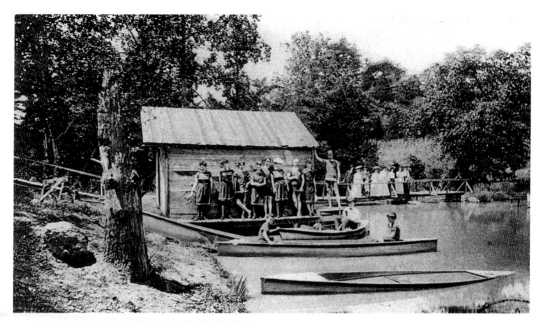

Chick Springs in Taylors had one of the better swimming holes in the area, in Charles E. Hill's opinion. Note the ladies standing on the bridge leading to the springs. Chick Springs Hotel burned on September 30, 1917. The resort never quite regained prominence in the community again, but to this day, Lick Springs and the creek trickle by the old, dusty swimming hole and dilapidated buildings. (Charles E. Hill Collection, South Caroliniana Library, USC, Columbia.)

Beneath the wood canopy is Lick Springs, which the American Indians believed to have healing powers. By the late 1800s, ginger ale was produced utilizing mineral water from the springs. (Special Collections, South Caroliniana Library, USC, Columbia.)

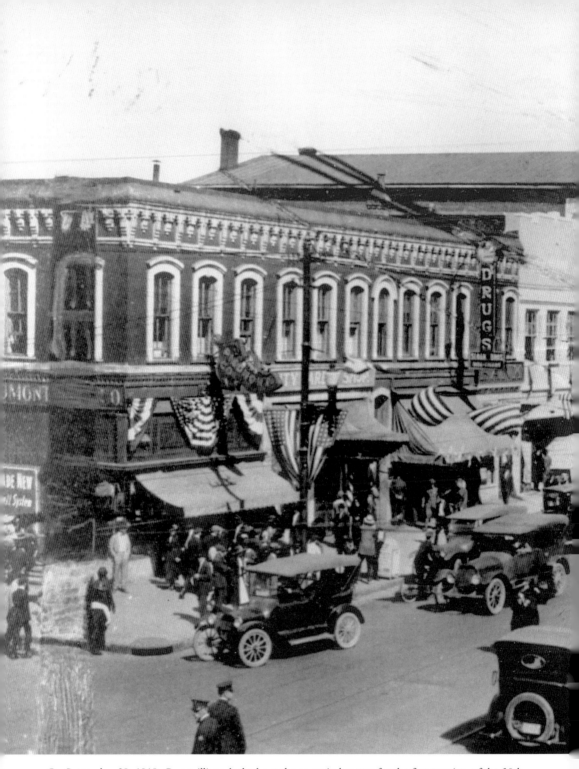

On September 29, 1919, Greenvillians decked out the town in banners for the first reunion of the 30th Division, or Old Hickory. (Courtesy of the Jim DeYoung family; also South Caroliniana Library, USC, Columbia.)

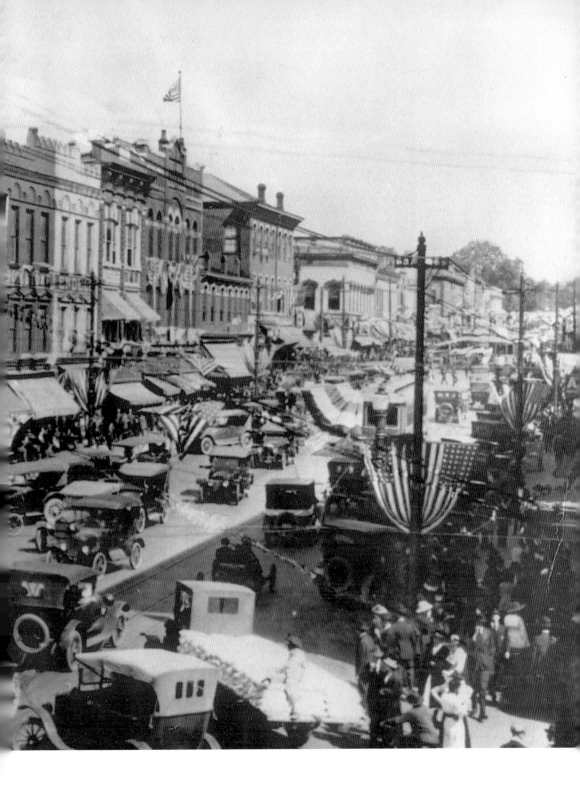

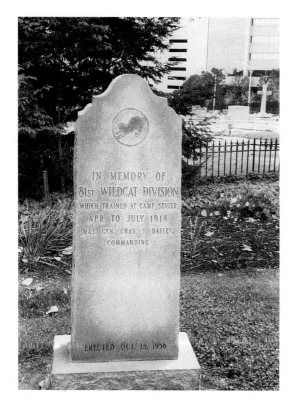

Left: The 81st Wildcat Division also trained at Camp Sevier, and this 1956 memorial stands near the Confederate Monument at the edge of Springwood Cemetery. (Photo by R.L. Aheron.)

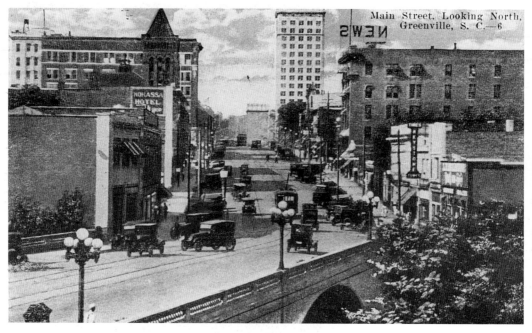

During the war, driving on Main Street could be dangerous. The Jalopies, horse-and-wagon, trolleys, and tractors crowded the street. There were no stoplights! (Special Collections, South Caroliniana Library, USC.)

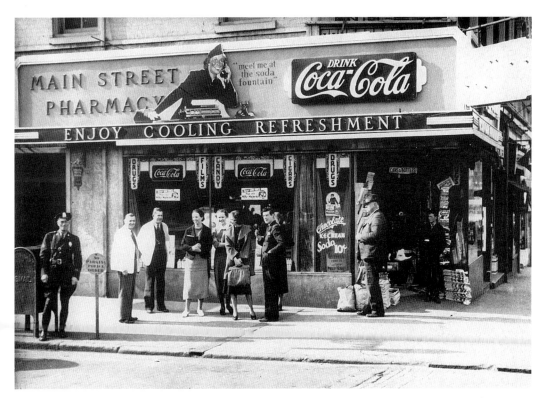

Above: A homesick soldier's best friend could be the soda fountain at the local drugstore. Letters could be mailed, ice cream could be enjoyed, and smiling faces beat practice on the artillery range any day. Some of Greenville's soda fountains from the early years still exist along Main and North Main. Carpenter's and North Gate Soda Shop are two examples. (Courtesy of the Jim DeYoung family.)

Right: Pharmacies had beautiful cabinets and unique furniture such as this ice cream table with its attached stools. (Courtesy of the Jim DeYoung family.)

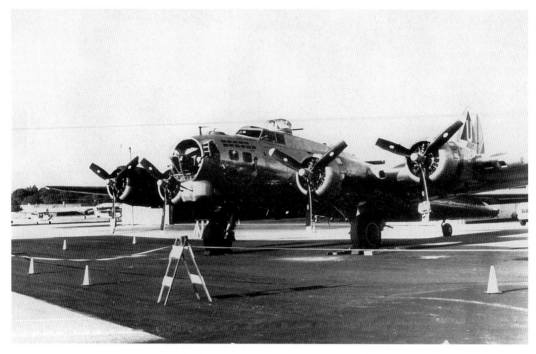

Above: More than 2,200 men were stationed on 2,372 acres that became the Greenville Air Base (1941). The base served as a training installation for B-24, B-25, and B-26 air crews during the early days of World War II. Missions were flown from here to all around the world. During the Cold War, the Defense Department retained the base as headquarters of the Military Air Transport Command. In 1951, the Greenville Air Base was renamed in memory of Major John O. Donaldson, a native of Greenville and an ace WW I pilot. (Courtesy of the Jim DeYoung family.)

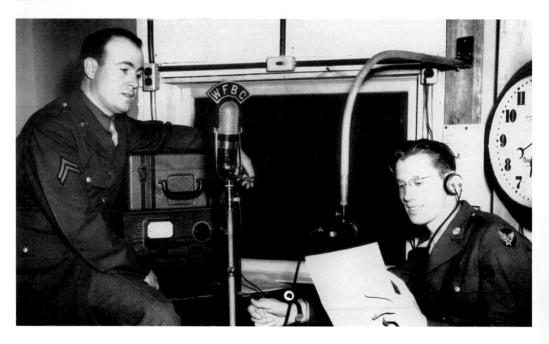

Above: As can be seen in this Kenneth Marsh *c.* 1960s photograph, the checkerboard tank at the air base became a Greenville landmark for pilots and soldiers. In the foreground of this view are a few living quarters for the men. In 1961, the federal government announced that the base would close. In 1963 the facility began to convert into an industrial park. In the 1970s, some Greenville Tech courses were taught at the base, due to a lack of schoolrooms. In the 1980s, the air base became a lift-off point for Freedom Weekend Aloft, a hot-air balloon festival. By 1990, Donaldson Center had transferred more than $2 million to the city and the county. Three thousand people are employed in various industries located at Donaldson Center. (Marsh Collections, South Caroliniana Library, USC, Columbia.)

Opposite below: WFBC, a 5,000-watt radio station of the *Greenville News-Piedmont*, equipped a studio in the air base's theater balcony. Seen here in 1943, Zeb Lee and Norvin Duncan (right) broadcasted war news and local variety shows from it. Norvin met his wife at a studio broadcast here; the two married, both in full uniform, at the air base in 1944. They reside in Greenville with Norvin serving WGGS-TV16 on Rutherford Road, a site once occupied by Camp Sevier. (Courtesy of the Norvin Duncan family.)

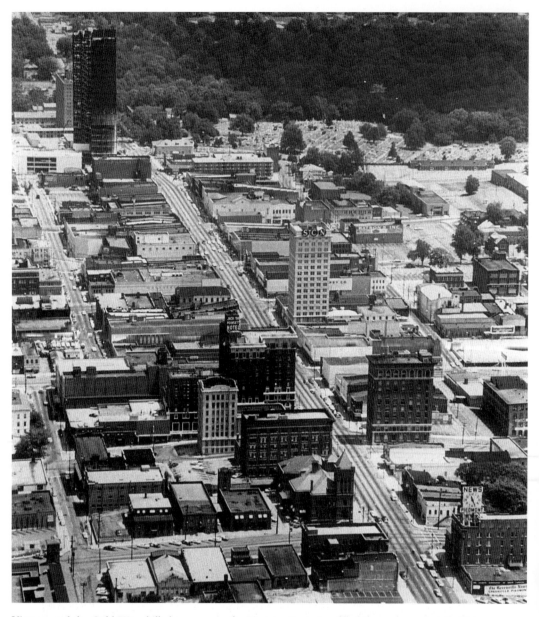

Vietnam and the Cold War chilled progress in the Upstate. Protesters filled the parks, and civil rights advocates chanted at the lunch counters of S.H. Kress and F.W. Woolworth on Main Street. Greenville schools integrated with difficulty, and the city struggled financially as department stores moved to the suburbs. Ivey's and Meyers-Arnold were the first to leave. They rented space in McAlister Square, the largest mall in the state at the time. As for desegregation, resentment smoldered from all sides. Furman Professor Ernest Harrill, the chamber of commerce chair of a biracial committee designed to assist the schools, stated " . . . we've been moved only by the law and not by our own spirit." U.S. Senator Charles Daniel shared Harrill's sentiments and encouraged people to embrace the changes. In this c. 1960s view of Greenville, the Daniel Building rises higher than the Woodside Building (the white structure with "SCN" stamped on its top). (Marsh Collections, South Caroliniana Library, USC, Columbia.)

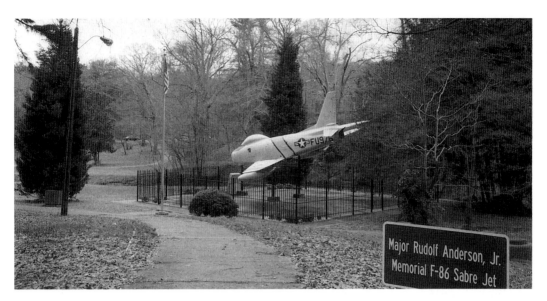

Major Rudolf Anderson Jr. (1927–1962) was one of the fatalities of the Cuban Crisis and the Cold War. His memorial, an F-86 Sabre Jet located at Ridgeland Drive, is one of the few outside the Springwood Cemetery park. In 1924, William Choice Cleveland gave Greenville 110 acres of land for Cleveland Park. Greenville Zoo borders Cleveland Park, which contains the Vietnam War Memorial, the Hostage Crisis Memorial (1979–1981), and the Anderson Memorial. The Cold War of the 1960s ended when President Ronald Reagan challenged the German people to bring down the Berlin Wall. (Photo by P.E. Peters.)

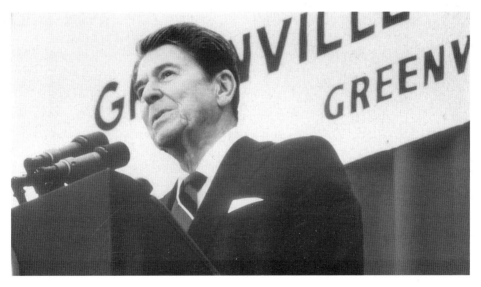

During World War II, community drives for scraps and for the purchase of war bonds became a part of regular life. Celebrities frequently visited Greenville. In 1942, film star Jane Wyman, first wife of actor Ronald Reagan, visited the area. She lent her support for local efforts. In the 1980s, President Ronald Reagan frequently visited Greenville to lend support for economic growth in the region. His legacy includes creating peace between the Soviet Union and the United States. (Courtesy of Greenville Tech.)

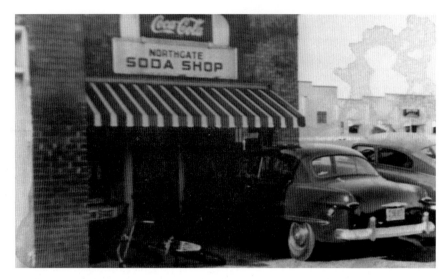

With peace and prosperity at hand, Greenvillians revisited the past. City planning reclaimed 26 acres along the Reedy River for the development of a park. The Peace Center for the Performing Arts, a cultural center, shifted from the fund-raising phase to the construction phase, and new businesses provided services and products with a nostalgic flair. Above is a view of the first Northgate Soda Shop, c. 1940s, which later, moved to North Main Street. (Courtesy of the Jim DeYoung family.)

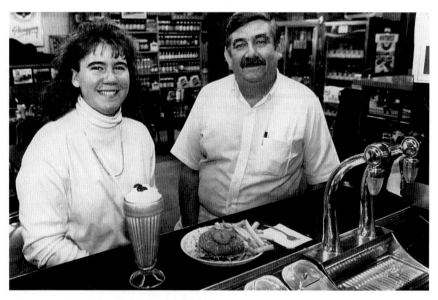

Like their grandfathers and WW II fathers, YUPs (young, urban professionals), or "yuppies," frequently patronized local pharmacies and soda shops in Greenville in the 1980s. Leighton DeYoung enjoys refreshments with her dad, Jim, a retired policeman and the owner of the Northgate Soda Shop. Elizabeth, Leighton, McClure, and their mother, Jerry DeYoung, consider Northgate Soda Shop an extension of their home. The shop is a gallery filled with images and paraphernalia related to Greenville's past. (Courtesy of the Jim DeYoung family and the *Greenville News-Piedmont*.)

From Playgrounds
to Politics

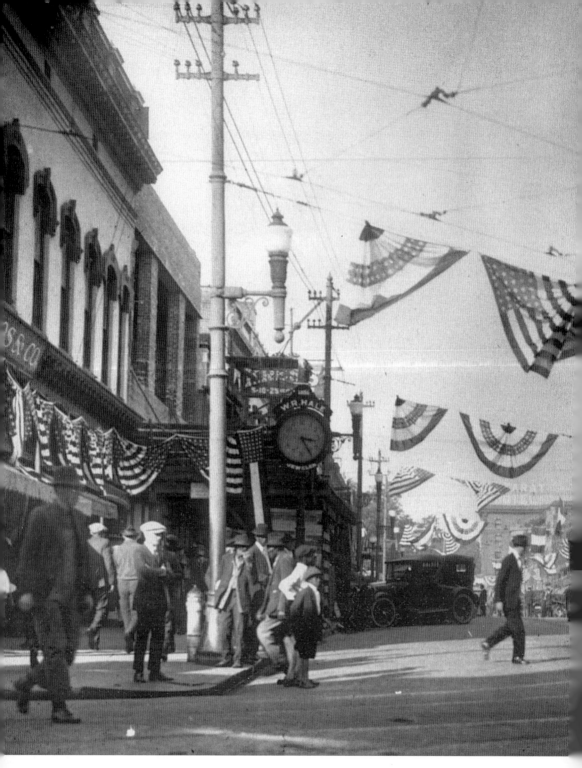

In 1913, the Park and Tree Commission began to establish playgrounds and parks in an ever-expanding city. The growth is never more apparent than in this 1919 view. (Courtesy of the Jim DeYoung family.)

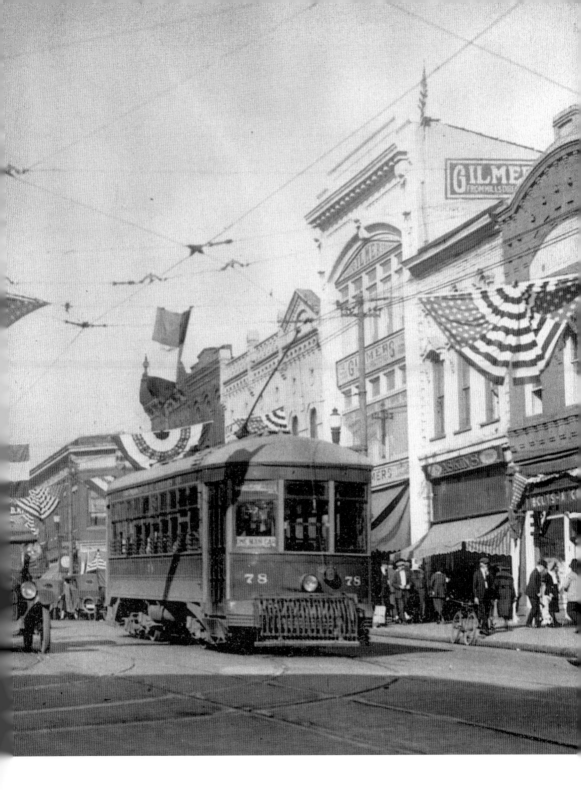

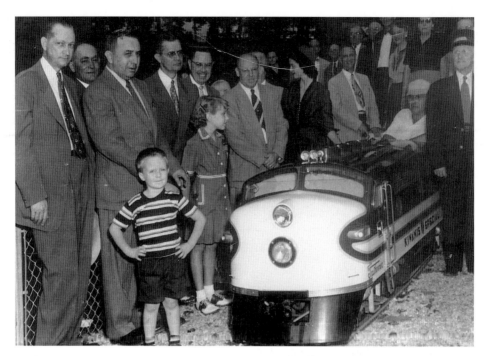

In the 1920s, John A. McPhearson headed the Parks Commission, which created playgrounds and municipal parks. Work began when the Kiwanis Club pledged $6,000 and salaries for two workers for one year. In 1922, bonds passed and helped to create playgrounds on Donaldson Street, Anderson Street, and Hudson Street. This little train was one of the finer features of the Parks Commission. (Courtesy of the Jim DeYoung family.)

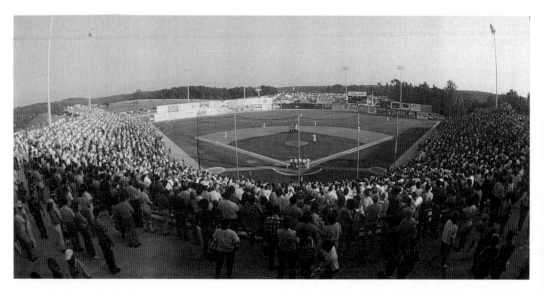

Greenville Municipal Stadium was built in the 1980s between the city of Mauldin and Greenville. The Braves decided to move from Savannah, Georgia, to Greenville, and the impact of their presence has provided growth opportunities for Mauldin/Butler Road and the entire Upstate. (Courtesy of the Greenville Braves.)

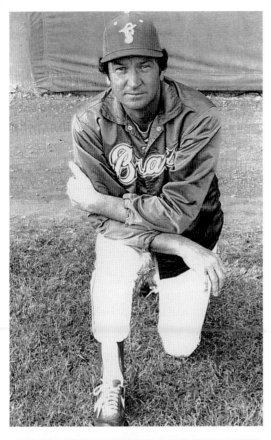

Above: Son of a Pickens County tenant farmer who relocated to Brandon Mill village, Joseph Jefferson Jackson showed promise as a baseball player when he was a boy employee of the mill. In 1915, Jackson went to the Chicago White Sox for $65,000. In 1919, Jackson and seven teammates were accused of throwing the World Series. He was found not guilty, but the baseball commissioner refused to allow Jackson to ever play again. In his last years, he played baseball with the Brandon neighborhood children. He is buried at Woodlawn Cemetery.

Above left: Businessman Sam Phillips, Mayor Bill Workman, and Bruce Baldwin, general manager of the Greenville Braves, broke ground for the new municipal stadium. In the winter of 1983, the team moved to Greenville from Savannah, Georgia. Bobby Dews, former manager of the Durham Bulls, poses in his Savannah uniform one last time. Dews soon managed the Greenville Braves, a Class "AA" affiliate of the Atlanta Braves. (Courtesy of the Greenville Braves.)

Below left: Shoeless Joe Jackson might treasure the fact that in 1992 the Greenville Braves captured their first league championship title at Engle Stadium in Chattanooga, Tennessee. They beat the Lookouts 10-3 in the fifth and deciding game of the playoffs. (Courtesy of the Greenville Braves.)

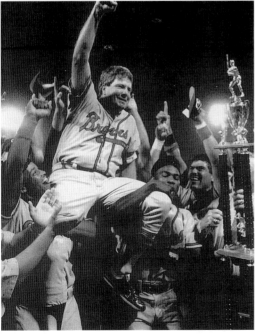

Right: An educator with a passion for golf, tennis, and football, Wilfred J. Walker Sr. is considered by his colleagues to be one of the best play-by-play sports broadcasters in the Southeast. He is the "Ole Sportscaster," the voice of the Sterling High Tigers. His career began at station WESC in 1948. Walker met celebrities such as Marian Anderson and Louis Armstrong while maintaining full creative control of his variety show on WFBC radio. He utilized his fame to support charitable organizations, and in 1990, the University of South Carolina and McKissick Museum honored Walker as a pioneer in African-American broadcasting. (Courtesy of the Wilfred J. Walker Sr. family.)

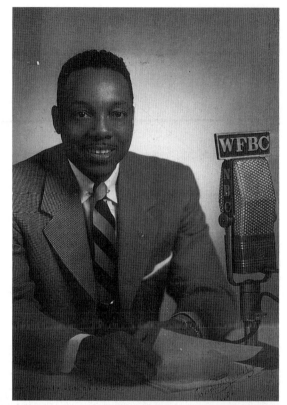

Below: By the late 1950s, WFBC had merged with WMRC to form the Southeastern Broadcast Company with Roger C. Peace, Bony Peace's son, as chair. By the late 1960s, Southeastern Broadcasting and *News-Piedmont* had combined to create the ever-expanding Multimedia. Pictured above are the first remote broadcasting facilities of WFBC-TV4/WFBC radio. At one time, the two stations were operated jointly by the same company. (Courtesy of WYFF Television, Greenville.)

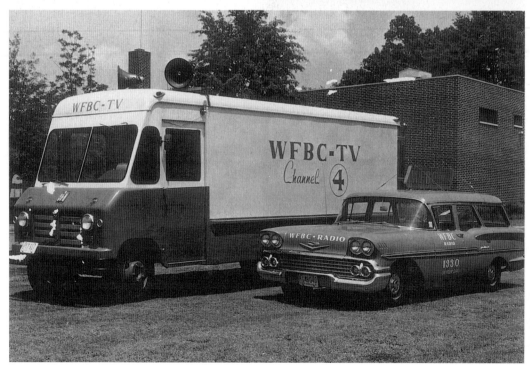

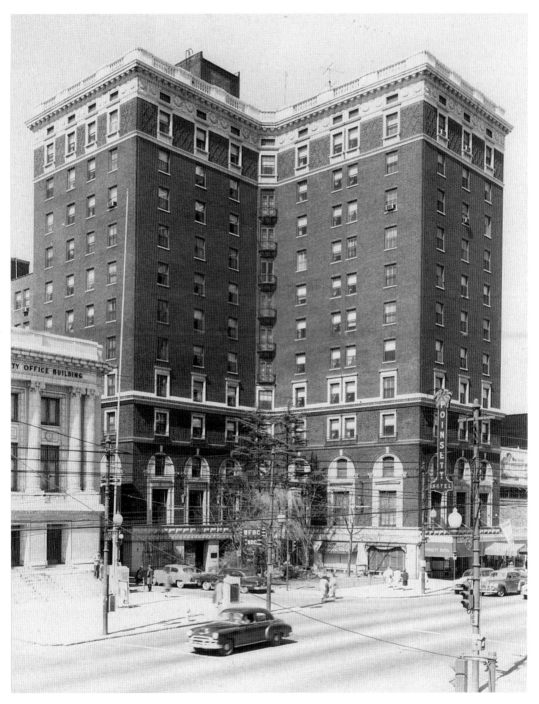

Constructed by the Woodside brothers in the 1920s, the Poinsett Hotel was sheer luxury. It was also the first permanent home of WFBC/NBC radio (photo *c.* 1954); the studios were in the basement. Almost instantly, the station and its personalities (Wilfred Walker and Norvin Duncan, to name a few) became regional leaders and local celebrities within the Upstate, an area that was an agricultural society with few links to the outside world. (Special Collections, Furman University, Greenville.)

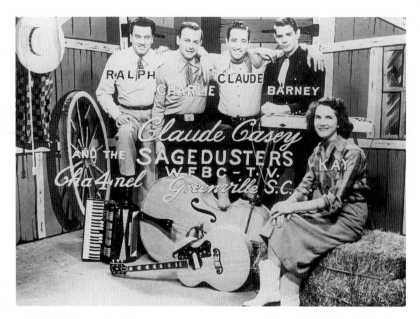

In the early years, locally produced television programs strengthened the community and exhibited the best in local talent. *Claude Casey* was one of the first television shows produced in Greenville. Casey and the Sagedusters (seen here in the late 1950s) were stars at WBT-Charlotte. Casey decided to move to a new area, and he enjoyed great success in Greenville. (Special Collections, South Caroliniana Library, USC, Columbia.)

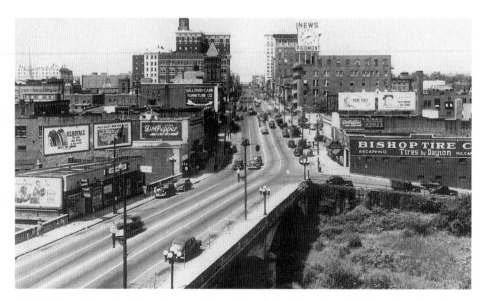

In 1919, Bony Hampton Peace, born in Tigerville, acquired the *Greenville News*, located at the corner of Main and East Broad Streets. Soon the paper had the biggest circulation in the state. In 1927, Bony acquired the *Greenville Piedmont*. Bony Peace put sons Roger, Charlie, and B.H. Jr. to work at the papers. Circulation grew steadily, and the Peace family began to consider radio and television as another part of their communication enterprises. (Special Collections, South Caroliniana Library, USC, Columbia.)

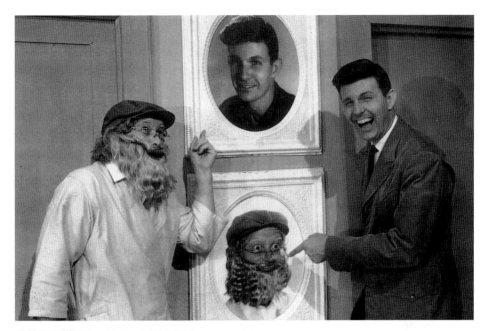

Babyboomers loved *Monty's Rascals*, featuring the antics of Monty and Doohicky (Stowe Hoyle). Monty Du Puy (right) directed the news and hosted a talk show. Presently, Du Puy produces videos with Monty Du Puy & Associates or Sound Editions. (Courtesy of WYFF Television, Greenville.)

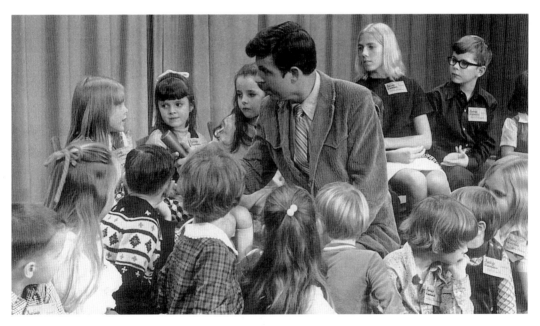

Children on *Monty's Rascals* told Monty their names and talked about their neighborhoods and schools. It was one of the first television shows in the Upstate to provide children with a sense of community in the rural environments of Oconee, Pickens, Greenville, Anderson, and Spartanburg Counties. (Courtesy of WYFF Television, Greenville.)

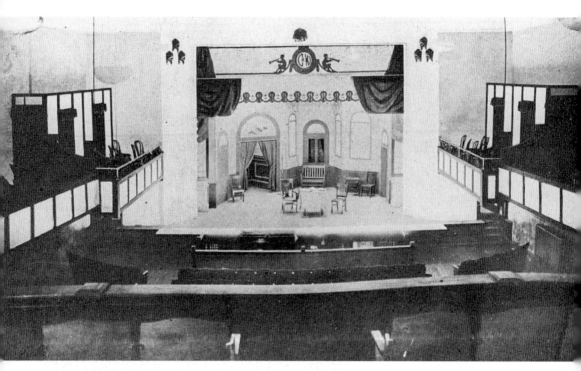

Above: By 1920, African Americans had gained some visibility in Greenville. Clayton "Peg Leg" Bates, born in Fountain Inn in 1906, performed on this stage at the Liberty Theater (near Spring Street). It was an auditorium designed exclusively for African Americans and African-American entertainers. In 1924, Bates went to New York and danced in dinner reviews and nightclubs, including the Cotton Club in Harlem. In 1951, he purchased land in the Catskill Mountains and began operating the first resort for African Americans. (Special Collections, South Caroliniana Library, USC, Columbia.)

Opposite below: In 1955, Joanne Woodward came home to Greenville. She was in the area for the world premiere of her first motion picture, *Count Three and Pray*, which premiered at the Paris Theater. Woodward, an Academy Award–winning actress, began her career at Greenville High, then the Greenville Little Theatre (shown here). (Special Collections, South Caroliniana Library, USC, Columbia.)

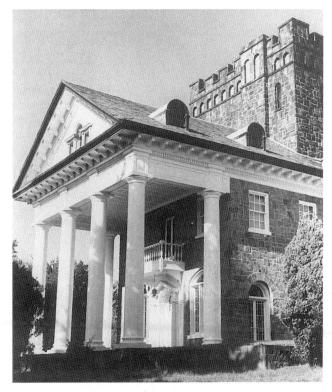

Right: Greenvillians have always enjoyed art, music, theater, and dance. Finding facilities for the visual arts proved challenging until 1958, when the County's art association purchased the Gassaway Mansion, also the Isaqueena Mansion (built 1919–1924), for use as a museum. Seen here in Marsh's *c.* 1962 photograph, Gassaway cost $790,000 and contained 70 rooms and a tower constructed from the stones of the old Vardry Mill. (Special Collections, South Caroliniana Library, USC, Columbia.)

In 1974, the art association moved to the first museum built in South Carolina in the twentieth century. This sleek, contemporary facility can handle a number of temporary or traveling exhibits. It is located at Heritage Green, an area formerly designated as the Greenville Women's College campus. (Photo by P.E. Peters.)

Greenville Little Theatre, one of the most indigenous and communal of all the arts programs in Greenville, relocated to Heritage Green, the site of the male and female academies. (Photo by P.E. Peters.)

Left: Several authors have painted distinct portraits of Greenville in their works. Harry Ashmore, who won the Pulitzer in the 1950s for his pro-integration editorials in Little Rock, Arkansas, was raised in Greenville in the 1920s. Award-winning educator and writer Paulette Bates Alden (seen here) writes about her Greenville home in her memoir *Crossing the Moon: A Journey Through Infertility.* Dorothy Allison spent her first 13 years in Greenville. She gives a painful view of a 1950s Greenville in *Bastard Out of Carolina.* (Courtesy of Deb Richardson-Moore, *Greenville News*; special thanks to Paulette Bates Alden.)

Below: Born in Greenville on March 30, 1922, Henry Maxwell Steele attended Furman (1939–41). He also studied at Vanderbilt and eventually at the Académie Julienne in Paris, France (1951–52). Steele won the $10,000 prize in the 1950 Harper Novel Contest. He twice received the O. Henry Prize for short stories. A number of his works appeared in the *Atlantic, New Yorker,* and many other literary journals. In the 1980s, Steele retired as director of Creative Writing at the University of North Carolina, but many of his talented students have found success in the literary arts. (North Carolina Collection, University of North Carolina Library at Chapel Hill.)

Left: Bennie Lee Sinclair, a 1961 Furman graduate, is considered the people's poet. Her ardent fans included poet/novelist James Dickey, who backed her for state poet laureate, and former governor Dick Riley, who invited her to read her poems at his inauguration in 1979. Through her career as an educator at Furman, Sinclair has received numerous awards including the Stephen Vincent Benet Narrative Poem Award. In 1992, Walker Mysteries published Sinclair's first novel, *The Lynching*, a fictional work developed around the death of Willie Earle. (Special Collections, Furman University, Greenville.)

Jesse Jackson was five when 24-year-old epileptic Willie Earle (seen here) was shot, or, in legal parlance, lynched near a slaughter yard on Bramlett Road in Greenville County. Supposedly, Earle murdered Thomas W. Brown, a white taxicab driver. Brown was found dead near his wrecked car. Earle, the passenger, was taken to Pickens jail, where a mob of about 28 white men and 15 Bluebird taxis had gathered. When Earle's body was found, Governor Strom Thurmond notified the FBI. Thirty-one people were indicted. The mob's trial at the Greenville Courthouse in 1947 received national publicity from newspapers and magazines, including the *Minneapolis Times*, the *New York Times*, and *The New Yorker*. Despite their confessions, Earle's murderers were acquitted, but the trial set a precedent, ending mob actions within the state. On another level, however, Earle lives. He is the "Specter of the Slaughter Yard" in South Carolina ghost stories and fictions. According to legend, only cab drivers see Earle when he decides to reenact the lynching. (Special Collections, South Caroliniana Library, USC, Columbia.)

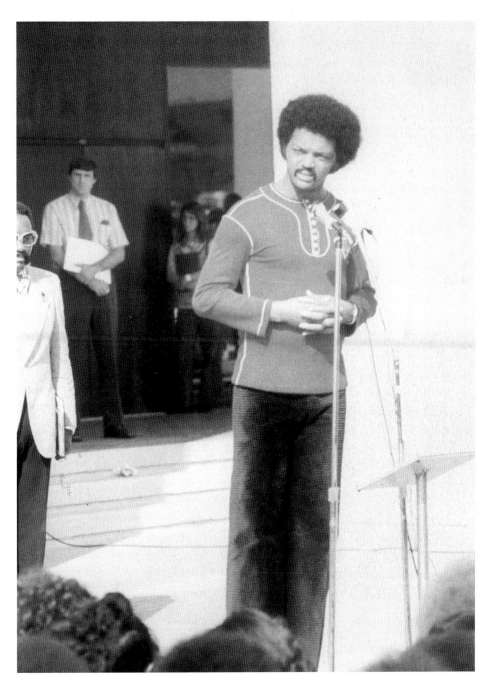

Born in 1941, Jesse Jackson grew up on Haynie Street. When his stepfather, Charles Jackson, returned from military service, the family moved to University Ridge and then Anderson Street. Jackson, strongly influenced by his parents and the Longbranch Baptist Church, attended the University of Illinois, then the North Carolina Agricultural and Technical College in Greensboro. Later, he attended the Chicago Theological Seminary. Seen here in the late 1960s, Jackson went on to work with Dr. Martin Luther King Jr. for the Southern Christian Leadership Conference and Operation Breadbasket. (Courtesy of Greenville Tech.)

In October 1973, Jackson was honored at a banquet at the Poinsett Hotel, where he once worked. He was honored for his national leadership in the civil rights movement. One of the largest interracial gatherings in the state's history, the banquet was hosted by Holocaust survivor Mayor Max Heller. In 1984 and in 1988, Reverend Jesse Jackson became a serious Democratic candidate for the presidency. Jackson still visits Greenville and preaches at the local churches. (Courtesy of Greenville Tech.)

A native of Greenville County, Richard "Dick" Wilson Riley, born January 2, 1933, is the first governor in modern South Carolina history to succeed himself with a four-year term (1979–1987). A Navy man, Riley attended Furman and received a law degree from the University of South Carolina. He then practiced law with the family firm in Greenville until he went into politics. Riley is most noted for the passage of the 1984 Educational Improvement Act. In 1993, President William "Bill" Clinton appointed Riley the U.S. secretary of education. In this view, Riley (left center with glasses) prepares for a press conference at Greenville Tech. (Courtesy of Greenville Tech.)

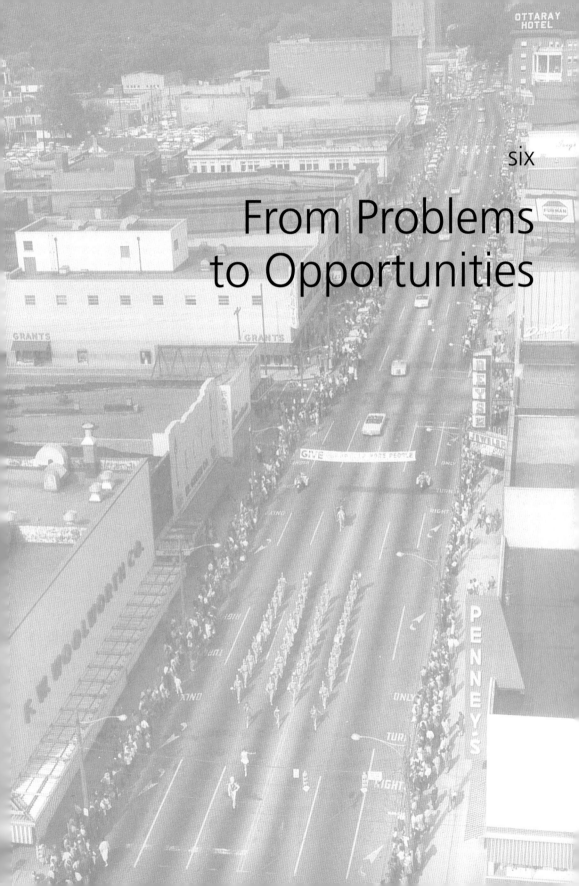

six

From Problems
to Opportunities

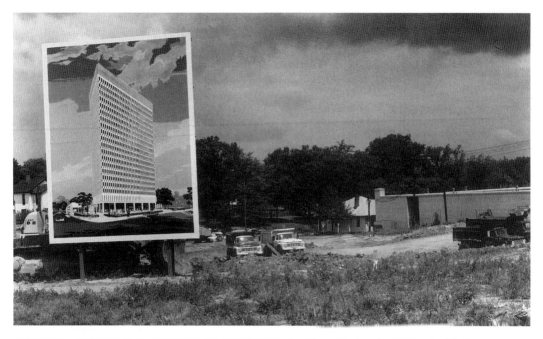

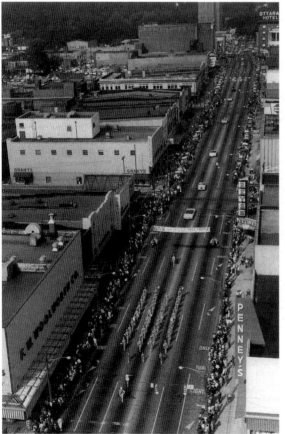

Above: During the 1960s, city blocks became vacant as businesses retreated to the suburbs. Business leaders Roger C. Peace of Multimedia, Inc., which owned the *News-Piedmont* and WFBC radio and television, and Charles Daniel of Daniel Construction refused to follow this trend. Both men placed new corporate headquarters on the opposite ends of Main Street. In this early-1960s view, the Daniel Building, located at the corner of Main and College, is a 25-story dream on posterboard. Eventually, it would be the tallest building in the city. (Marsh Collections, South Caroliniana Library, USC, Columbia.)

Left: Here, the Furman University band marches down Main Street. Notice the J.B. White store standing across from the Ottaray Hotel. Meyers-Arnold, Ivey's, Butler Shoes, Penney's, and many others relocated to McAlister Square Mall, and then Haywood Mall. F.W. Woolworth Company, however, remained downtown until it closed in the late 1980s. Notice the wide streets that have greatly narrowed with redevelopment of the city. (Special Collections, Furman University, Greenville.)

Born in Greenville on July 25, 1940, Carroll Ashmore Campbell Jr. served as South Carolina's 112th governor (1986–1994). Campbell, only the second Republican in more than a century to attain the state's highest office, chaired the National Governors Association (1993). In this role, he established six ambitious National Education Goals, which arose from a summit between the nation's governors and President George Bush. Campbell also worked for strong economic development. Under his leadership, the state attracted an unprecedented $22 billion in capital investments and created more than 230,000 new jobs. Campbell also launched "Caring For Tomorrow's Children," an innovative partnership between business and government that decreased the state's infant mortality rate by 21 percent in four years. (Courtesy of Greenville Tech.)

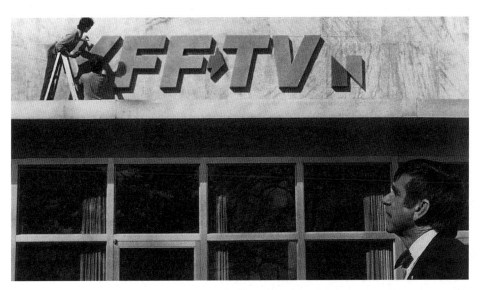

A fire damaged the original Rutherford Road television station, although some historical images survived the flames. In this view, the station has undergone renovations. Station manager Doug Smith watches Channel 4's call letters change from WFBC-TV, which stood for the First Baptist Church of Knoxville, Tennessee, to WYFF, which is short for Your Friend Four. WYFF also dissolved its partnership with WFBC-AM/FM radio in order to better serve the community in the growing field of visual communications and technology. (Courtesy of WYFF Television, Greenville.)

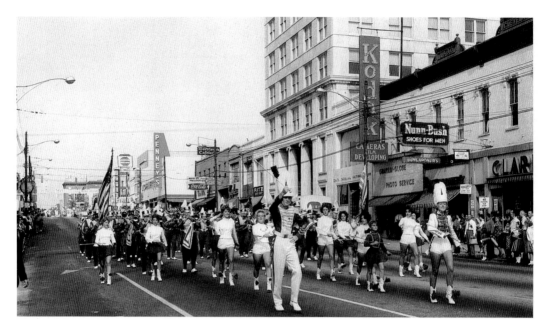

The city's population in the 1960s, when this photo was made, was approximately 66,208. By 1990, the population had dropped to 58,282. The county's population in 1960 was 209,776. By 1990, the total was more than 320,000. Urban sprawl continues to be a significant problem. Notice in this view the base of the Woodside Building (razed in the 1970s) and the 1880 Cleveland Building (extreme right). (Special Collections, Furman University, Greenville.)

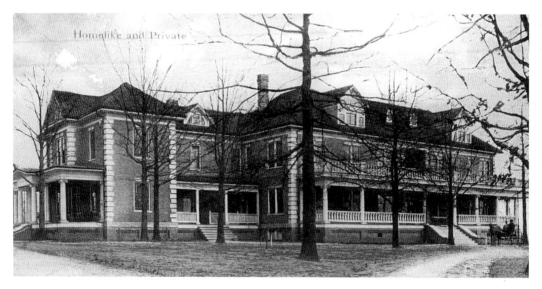

Healthcare has always been a challenge. Greenvillians responded by creating a network of consolidated services. The changes came slowly as the population increased. One of the first hospitals, the Corbett Home, located on Memminger Street (c. 1912), would eventually become the Greenville General Hospital. (Special Collections, South Caroliniana Library, USC, Columbia.)

City Hospital eventually expanded into Greenville General prior to World War II. In 1952, a joint city council hospital existed with Allen Bennett Hospital serving Greer-Taylors. In 1963, Hillcrest Hospital served Simpsonville. In 1966, 12 acres along Grove Road were purchased for a regional medical facility. (Marsh Collection, South Caroliniana Library, USC, Columbia.)

Emma Booth Memorial Hospital (built 1921) was entrusted to the Salvation Army because the Catholic Sisterhood rejected the formidable task of operating the hospital. During the Great Depression, the Salvation Army closed the hospital. Again, Greenville's healthcare leaders looked to the Catholic Church for help. The Franciscan Sisters of the Poor responded, and St. Francis Hospital has been expanding to meet the needs within Greenville ever since. (Courtesy of Jim DeYoung family.)

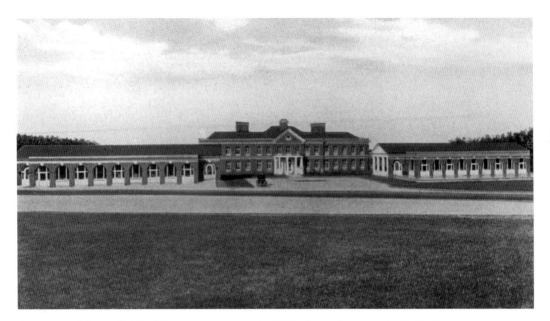

Expansion of Greenville's healthcare systems began in 1925 when real estate man W.W. Burgess, a native of Greer, and his associates created an endowment of $1.25 million. Burgess purchased land on Camp Road about a mile from Camp Sevier. Soon, a hospital for children had been built. Burgess was not a Shriner, but Shriners Hospital opened its doors in 1927. This structure, now a retirement center, is located at the corner of Rutherford and Pleasantburg. (Special Collections, South Caroliniana Library, USC, Columbia.)

Shriners Hospital, dedicated September 26, 1927, was celebrated across town. Shriners paraded in Greenville, then lunches were served at the Imperial and Poinsett Hotels. Roughly 4,000 people attended the parade and dedication. (Special Collections, South Caroliniana Library, USC, Columbia.)

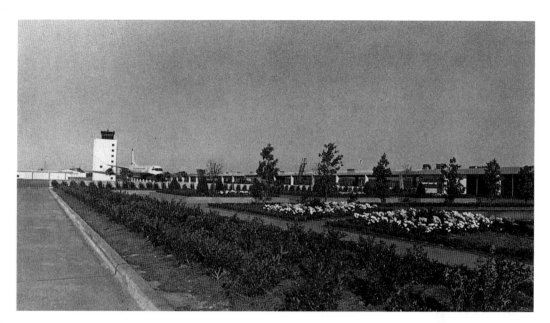

Greenville-Spartanburg Airport district was created in 1959. The actually facility opened for commercial business on October 15, 1962. Seen here in a photograph taken by Kenneth Marsh, Greenville-Spartanburg Airport, a $10-million development, began with a 7,600-foot main runway. This runway handled arrivals and departures every 45 seconds. (Marsh Collections, South Caroliniana Library, USC, Columbia.)

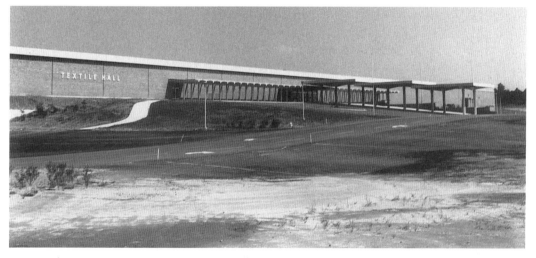

After World War II, the textile industry continued to expand with investments exceeding $160 million by the late 1960s, allowing giant corporations to emerge. Textile Hall could no longer manage the volume of visitors or exhibitors to the region. The last show at the old Textile Hall was in 1962. In 1964, the new Textile Hall opened next to the municipal airport. The Southern Textile Exposition continued, and by 1969, it was clear to Greenvillians and the international business community that Greenville had embraced its role as the "Textile Center of the World." (Marsh Collections, South Caroliniana Library, USC, Columbia.)

Left: In 1960, Governor Ernest Hollings challenged South Carolina's business and civic leaders to create a state system of technical education centers so that the labor force would be prepared for the computer age and the modernization of the textile industry. Greenville responded, and in 1962, Greenville Technical Education Center opened with Dr. Thomas E. Barton Jr. (pictured here) at the helm. (Courtesy of Greenville Tech.)

Below: Greenville Technical Education Center opened on September 5, 1962. In this view of the first learning center, Pleasantburg Drive is a small concrete path. Greenville city proper is located at the upper right of the image. In the fall of 1968, the school became a comprehensive community college. Its name changed to Greenville Technical College, or simply, Greenville Tech. The campus continues to expand along Pleasantburg Drive and throughout the rest of the county. (Courtesy of Greenville Tech; special thanks to Joe Jordan.)

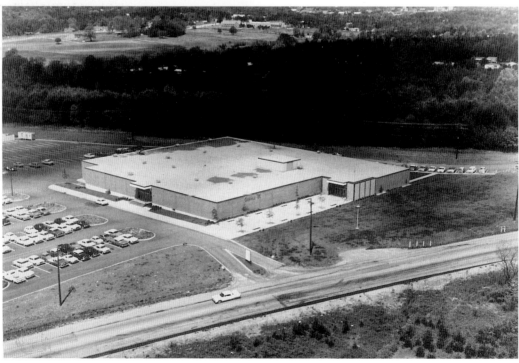

Greenville's role as a regional center for education will be greatly enhanced by the South Carolina Governor's School for the Arts and Humanities. When completed, the school campus will overlook the Reedy River. (Photo by P.E. Peters.)

The Reedy River area of Greenville is under restoration, and many old buildings are becoming new again. For example, Falls Cottage, built by George Dyer in 1838, has served the community as a tailor's shop, a cobbler's shop, a school, and a gas station. Presently, Falls Cottage is a restaurant. Behind the cottage is the Reedy River Historical Park, dedicated in 1992. (Photo by P.E. Peters.)

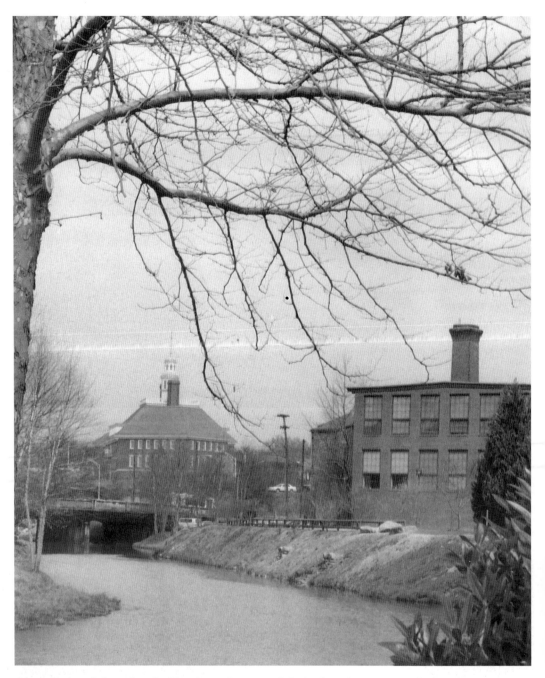

Greenville once belonged to the Cherokee. They revered the land as a hunting ground, choosing to live in permanent villages located in nearby Oconee County. Artifacts found at the river suggest that the Cherokee may have set up summer camps here, but when white settlers established mills, the buffalo, turkey, and deer herds shifted migration patterns and went west. After more than two centuries, the descendants of those early white settlers still utilize the Reedy, which serves as an industrial base as well as a location for an arts center. The river is beginning to flow again, without debris. Its environment is changing for the better. (Photo by P.E. Peters.)

Right: The Peace Center for the Performing Arts was created by supporters of the symphony, the arts council, and the theater. Fund-raising began with a $10-million gift from the family of Bony Hampton Peace, owner of the *Greenville News-Piedmont.* Construction began on Richard Pearis's Great Plains property of the 1700s. The center's design incorporates buildings of the old carriage factory and the Huguenot Mill. (Photo by P.E. Peters.)

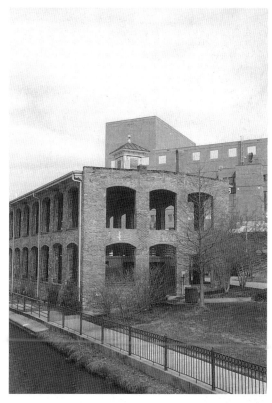

Below: In this view, the 1911 viaduct frames a new footbridge to the Peace Center. The Peace Center offers more than 60 international artists and attractions per year. It is the hub of local arts organizations, and it serves as an anchor for future economic development within the Greenville area. The Peace Center and the surrounding Reedy River Historical Park are a unique embodiment of Greenville's past, present, and future. (Photo by P.E. Peters.)

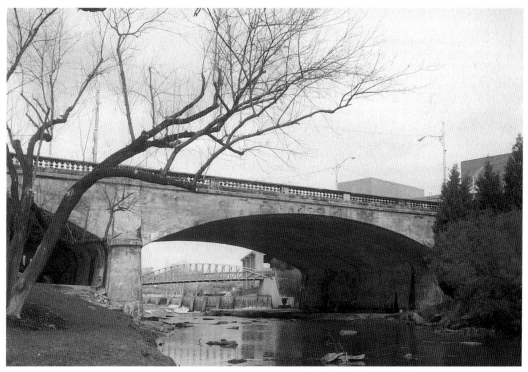

Acknowledgments

To tell the entire story of Greenville within these few pages proved impossible, but I am grateful to the people, institutions, and businesses that kindly shared materials for its creation. My most heartfelt thanks goes to B.J. Nash, Gretchen Brannaman, and Richard Dyais, all of Greenville Tech. Thanks also to Beth Bilderback and the staff of the South Caroliniana Library, University of South Carolina in Columbia. Thanks are also extended to Carolyn Lancaster, James B. Duke Library at Furman University; Joe Ayers of Furman University; Norman Belk and Betty Monahon of the Greenville County Library; Anthony Toussaint of the New York Public Library and the Schomberg Center for Research in Black Culture; Jerry Cotten of the Wilson Library at the University of North Carolina, Chapel Hill; Faye Holley and former governor Carroll A. Campbell Jr.; Deb Richardson-Moore of the *Greenville News-Piedmont*; Mark Hauser and the Greenville Braves; David McAtee and Cathy Petropoulos of WYFF-TV4; and Norvin Duncan of WGGS-TV16. I also appreciate the help of Wilfred J. Walker Sr., Paulette Bates Alden, Bennie Lee Sinclair, Elaine Paine, Max Steele, and Duff Bruce for donating time and energy to this project. To Jim DeYoung and the patrons of his Northgate Soda Shop, I extend a big thank you for helping me revisit the Greenville of my youth and for assisting me in the identification of many photos.

I researched a number of printed items from various libraries and archives. I am most appreciative of the works from Stanley S. Crittenden, Fredrick C. Holder, L.L. Arnold, Benjamin F. Perry, Lillian A. Kibler, James A. Dunlap III, Mary G. Ariail and Nancy J. Smith, Alfred S. Reid, James M. Richardson, Laura Ebaugh, Choice McCoin, Nancy Vance Ashmore Cooper, Henry B. McKoy, Richard D. Sawyer, Blanch Marsh, Kenneth F. Marsh, Frye Gaillard, Archie Vernon Huff Jr., Dot Jackson, Michael Hembrec, Bennie Lee Sinclair, and Claude H. Neuffer—just to name a few. These writers allowed me to obtain a great deal of information pertinent to the historical development of the area.

Lastly, I would like to thank Lisa Looman and Sharon Riedel for shelter, food, and laughs. I also thank F. Paul Richey Jr., Lisa S. Wylie, and Nina Graybill for their encouragement. Special thanks go to my father C.D. "Pete" Peters, who lives in Taylors. He and my patient husband, Richard L. Aheron, followed me where snakes dare not go to find some of the historical ruins of Greenville. To my mother, Jo Ann Peters, thanks for your prayers and your ears. To the entire hardworking staff of Arcadia, especially Mark Berry, Stephen Lynn, Sara Long, Ray Toler, Doug Rogers, and Ingrid Patterson—thank you for your gracious support. You all have helped make this project the best that it can be, and I wish you all much success now and in the future.